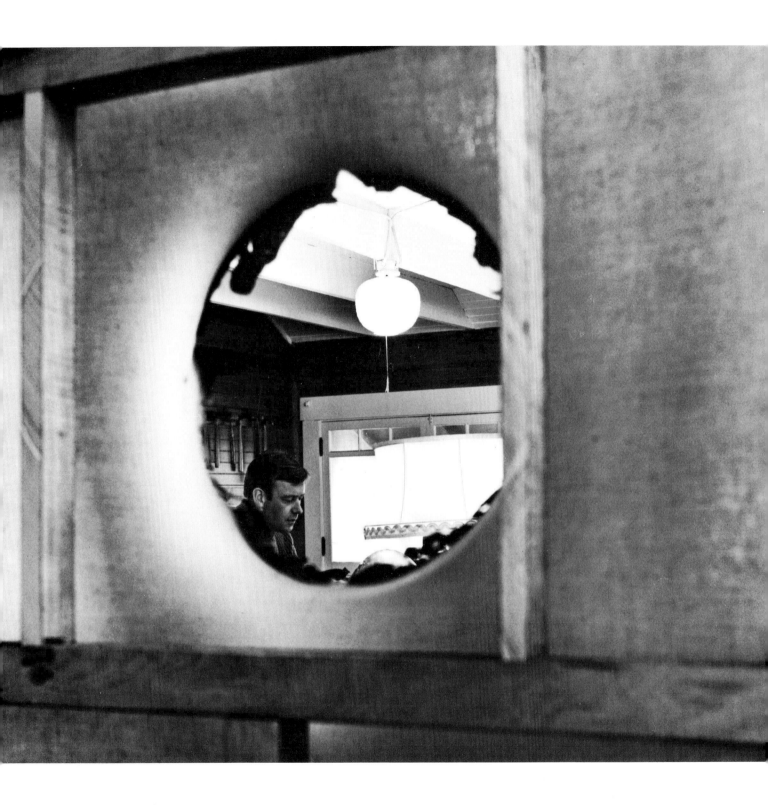

PHILIP

Introduction by Colin Graham

McCRACKEN

Published for the Tacoma Art Museum

by the University of Washington Press Seattle & London

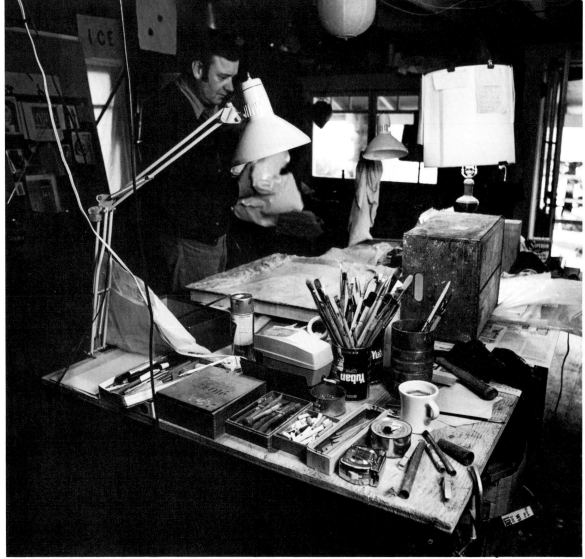

Philip McCracken was published in connection with an exhibition shown at
the Tacoma Art Museum, Tacoma, Washington, October 1980.

Copyright © 1980 by the University of Washington Press
Printed in the United States of America
Designed by Audrey Meyer

Library of Congress Cataloging in Publication Data

McCracken, Philip.
 Philip McCracken.

 "Published in connection with an exhibition shown at the Tacoma Art
Museum, Tacoma, Washington, October 1980."
 1. McCracken, Philip—Exhibitions. I. Tacoma Art Museum.
NB237.M255A4 1980 730′.92′4 80-51071
ISBN 0-295-95771-9

4

Acknowledgments

The publication of this book has been made possible through
the voluntary efforts and donations of a number of the artist's
friends and patrons, some of whom formed a small group called
"Friends of Philip McCracken" with a view to raising funds
and selecting a publisher.

The Tacoma Art Museum, which is well known for its policy
of fostering the interests of Northwest artists, agreed to sponsor
the volume and, under Director Jon Kowalek, to organize a
McCracken retrospective exhibition coincident with the book's
publication in October 1980.

Northwest artists owe no small debt to the artist-photogra-
pher Mary Randlett for her efforts, over a period of many years,
to secure on film an extensive record of their works and lives.
Without the selections she generously allowed us to make from
her copious documentation of Philip McCracken and his envi-
ronment, the introductory reproductions in this book would
have been a good deal less satisfactory. I am also grateful to
Trudy Sundberg for her valued editorial suggestions on the
text.

C. G.

Plates

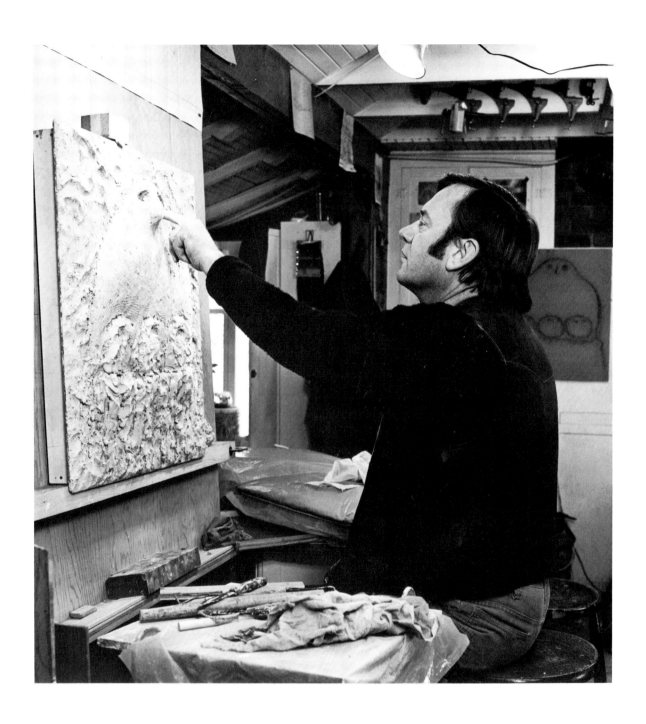

Introduction

As he goes about his daily rounds on Guemes Island Philip McCracken is constantly surrounded and imbued with those presences of the forest and sea from which he has drawn the themes of most of his sculpture. One might assume from this that he is a Northwest regionalist, and to a certain extent he is. The owls, hawks and ocean forms whose shapes he defines with such precision and intensity are in one sense pure Northwest phenomena. On the other hand, a second glance at his carvings is usually enough to reveal that under the surface these wild creatures are simply vehicles for human emotions and predicaments. While the outer shell, in other words, is animal and regional, the inner content is apt to be human and universal.

Although to a small degree this two-layered meaning is premeditated, the creative process for him is basically an involuntary and enigmatic one. "I try never to fuss," he once wrote, "with what is going on behind the curtain of my mind—when whatever is there is ready I expect it to come forth . . . if I knew what these pieces meant, I would probably never do them. They are not exercises in what I already know but explorations into what is mysterious and unknown to me."

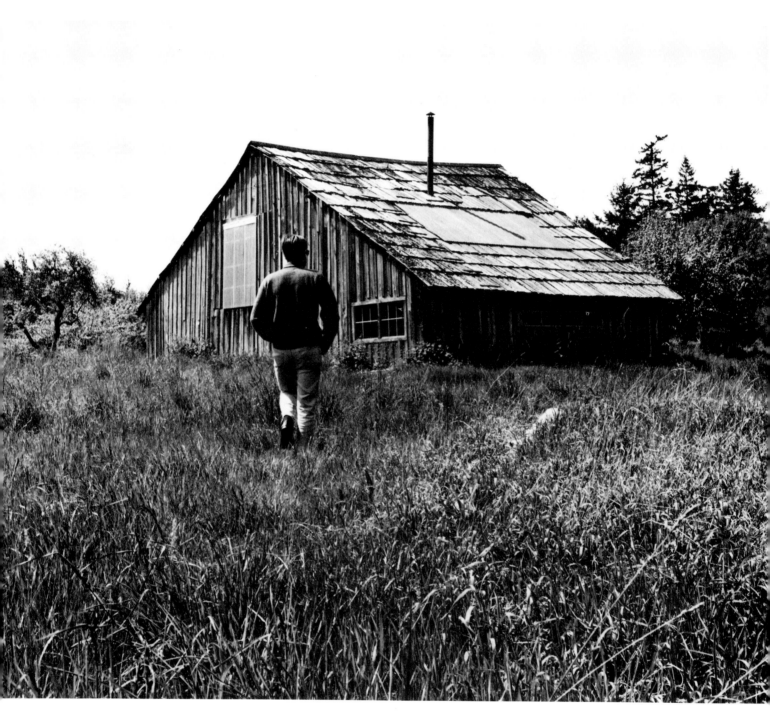

The barn studio

His first real studio on this small island at the mouth of Puget Sound off the coast of Washington was a vast barn set in a forest clearing in which the life forces were almost palpable in their presence. Beyond the barn the eye traveled past a shed where he kept his goats and chickens, past a hayfield gone to seed, to a phalanx of fir and cedar which formed the forest edge. In spite of the silence, one had a strong subliminal sense of things moving in the underbrush: a flitting wren or perhaps the snapping of a twig under a browsing deer. Occasionally there would be the swoop of a hawk as it tried to seize one of the chickens.

This brooding atmosphere is part of his birthright, for the roots of his family stretch back more than a hundred years into the history of Guemes and the surrounding Skagit County, beginning when his rugged grandfather came west to try his hand at mining.

His father grew up in the small town of Anacortes, which is a bare mile over the water from Guemes. When her time was near, Philip's mother went to a hospital in nearby Bellingham. There she gave birth to him on November 14, 1928.

His boyhood in Anacortes was as normal as it was comfortable. As the son of a successful merchant who took him and his brother on fishing trips and who gave him joyous summers at the family cottage on Guemes, he combined the easy-going life of a small town with vivid days in the outdoors.

Although at the age of four he had tried to carve a large neighborhood boulder, a consistent urge to create came slowly. It was only during his last year in high school that a need to paint gradually took precedence over the pleasures of football. After a false start as a law student at the University of Washington in Seattle, he gave in to mounting creative imperatives and switched to the university art department, graduating in 1953 having won various awards, including the School of Art Prize, and also having made the decision to become a sculptor.

There had been a significant interruption of these studies when the Korean war broke out. Volunteering as an army reservist, he found himself in El Paso, Texas, typed as a gunsmith. It was an experience that no doubt had a good deal to do with the subsequent appearance of the gun as one of the recurring themes in his art.

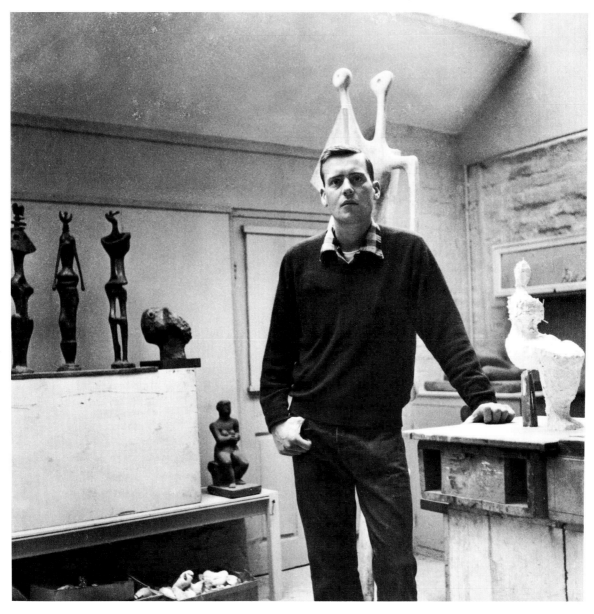

In Henry Moore's studio

Shortly before graduating from the university, he had parceled up a few sketches along with photographs of his sculpture and sent them to Henry Moore with the request that he be taken on as an assistant for a few months. The great English sculptor assented.

The summer of 1953 spent in Moore's studio near the village of Much Haddam in Hertfordshire had an unexpected result. It turned out that it was not so much Moore's art as his way of life that exerted a powerful influence. Back in the Northwest McCracken, stimulated no doubt by the examples set by Mark Tobey and Morris Graves, had developed a romantic notion about the typical artist as an unattached and dedicated loner. In Moore he found a man whose creative life was, as he put it, "at the same time intense and happy," who would come whistling to the studio in the morning full of zest for the day's work. Moore's social life style, moreover, was far closer to McCracken's own temperament than that of a loner, for the Englishman enjoyed a totally satisfying family life while at the same time finding leisure for both the enjoyment of friends and the discharge of public obligations.

This was a timely confirmation of McCracken's own leanings, for on the boat over to England he had met and fallen in love with Anne McFetridge, a graduate of Mount Holyoke and Cornell universities on her way to London to further her studies in English.

The upshot was that when the stint with Moore was over, she came up to be married in the little church at Much Haddam, Moore gallantly acting as best man.

By the autumn of that year the pair were living in the countryside near New York. Yet satisfying though it was to work in rural quiet while making forays into the vast gallery and museum resources of that city, McCracken soon realized that something was missing. That something was the richly moody skies, seas and forests of the Pacific Northwest.

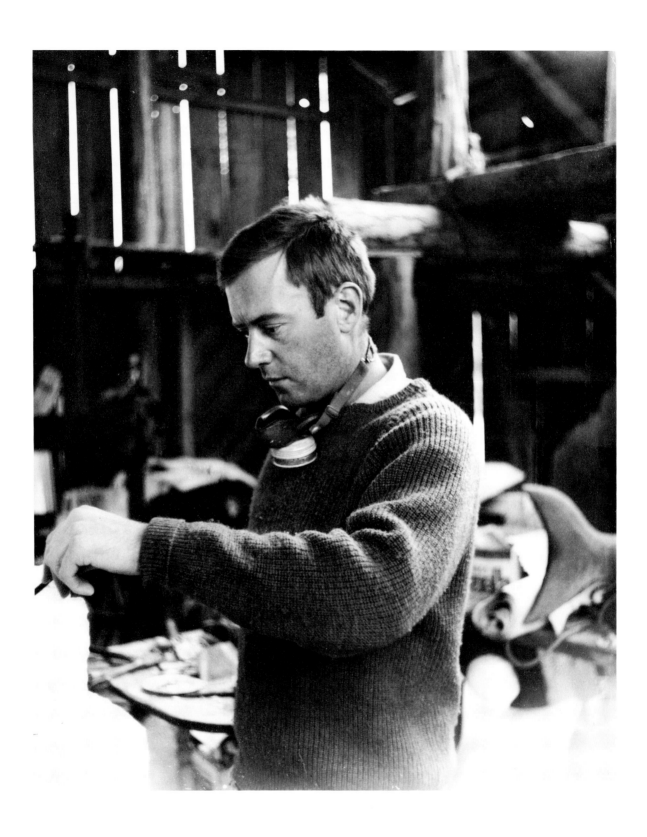

14

By the spring of 1955 they were living in the family seaside cottage on Guemes. There they were to stay and to bring up three sons until early in 1974, when they built a larger and remarkably beautiful house a short distance up the beach.

The life which they have fashioned for themselves and their family on Guemes has been an exemplary one in which the putting down of roots has been almost as rewarding for many of the island people as for themselves. With Anne taking the five-minute ferry ride to Anacortes to teach English in the town's high school, and Philip putting in seven-day weeks at the studio, they have still found time to make their home a warm and welcoming place open equally to the island people and to the continuous stream of artists, poets, musicians and architects who arrive from other parts of the state and beyond. So much so, indeed, that the number of those anxious to warm their spirits in the affection, gaiety and stimulation of the household has begun to place a strain on the hosts' stamina. And not a few have been those who, troubled in spirit or out of health, have been taken in for a few weeks or months of restorative care.

One intriguing result of Philip's temperament, with its mixture of strong human concern, sober judgment, and humor, was that at one time several businessmen tried to persuade him to run for the office of state governor.

Behind this human scene there is the ever-present world of birds and animals. Although the McCracken home has always been alive with the kind of pets usual to families with children—dogs, cats, rabbits and so on—it was the wild fauna filling the house in the early days that gave it a special flavor.

There was, for example, the great horned owl whom he could whistle out of the woods. With a rustle of its huge wings it would emerge from the forest depths, arc down toward the cottage door, bank vertically to get its wings through that door, and glide into the living room where it would alight on a favorite chair.

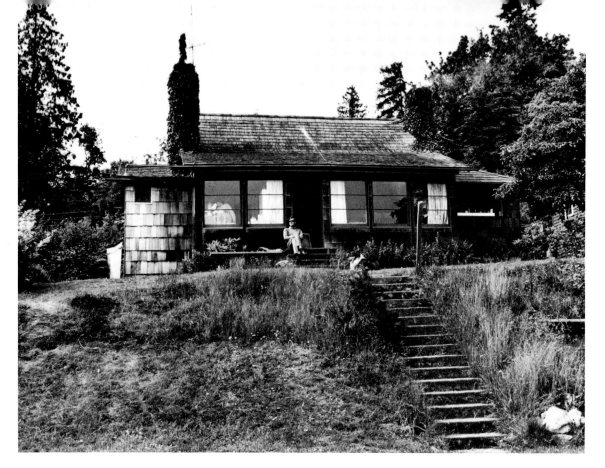

The family cottage on Guemes Island

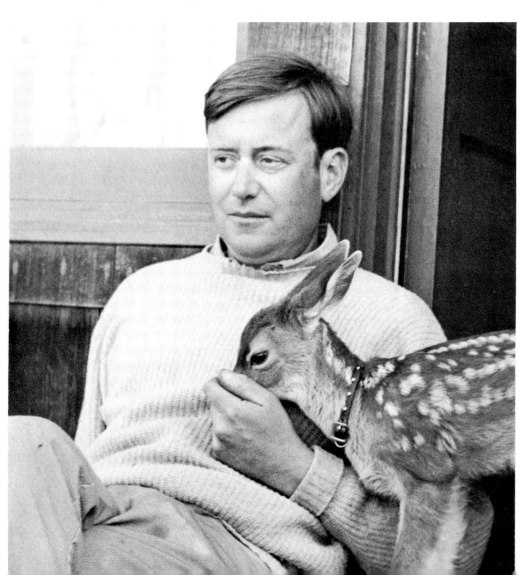

There was the crow which, once tamed, rejoined a nearby wild flock but which, when the flock was flying overhead, would glide down at the sound of a whistle and enter the cottage for a spell.

Then there was the young deer, the friendly skunk, the intractable bad-tempered possum, and a number of others.

These distractions notwithstanding, it is of course the sculptor's studio which is the fulcrum of his life. When winters in the unheatable draughty barn proved too much even for his tough frame, a comfortable old house fronting the beach was bought and turned into a working space.

It is a well-organized studio with the tools kept immaculate and always in their place. There is an orderliness that fits into a working method which is slow, measured, and infinitely exacting. This is not the fussiness of a compulsively tidy nature but rather the outcome of a passion for doing things with probity and for giving an idea the utmost form clarity. As one eastern critic wrote, "McCracken handles wood like a sorcerer," which is perfectly true; yet craftsmanship for its own sake does not interest him. As far as he is concerned, its role is simply to reveal form in the most telling way possible. It is a byproduct of process at its most intense.

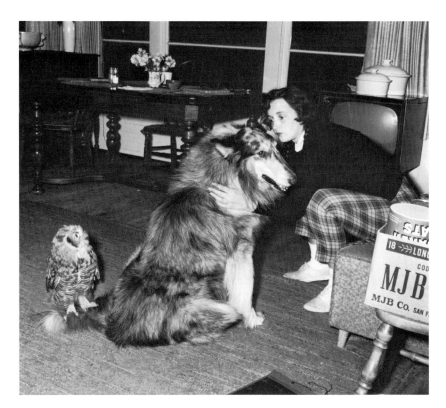

Anne McCracken and friends

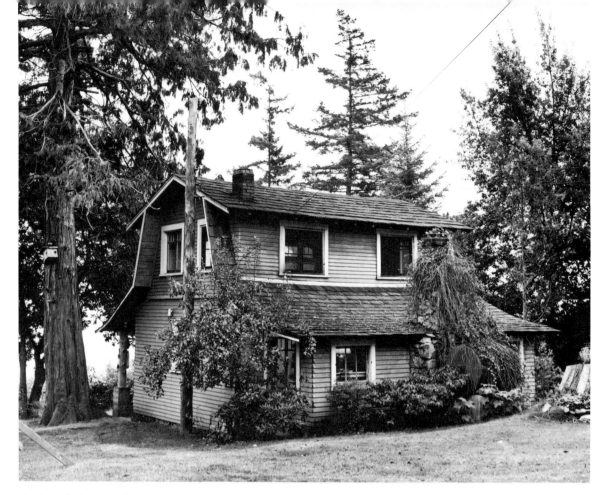

The beach-front studio

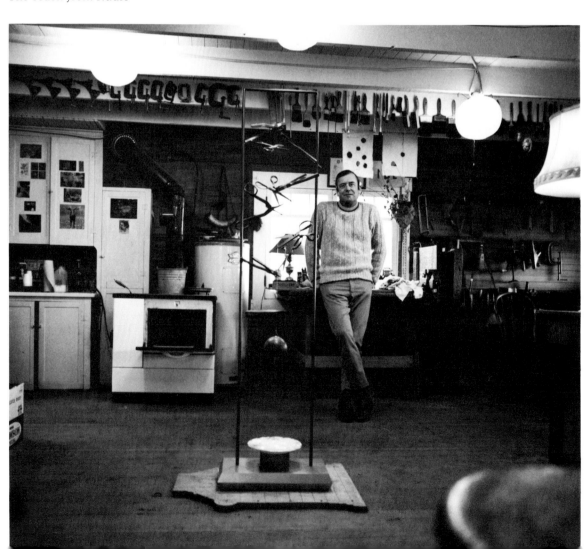

A technique so demanding entails certain penalties. One result is that there never is time to give shape to all the images which press for liberation from his mind with such insistence that if his tools are laid aside for more than a few days he becomes restive. And since the number of pieces finished each year is generally not large, the situation has its financial consequences.

It is a predicament in which loyal and supportive patrons are essential, and here he has been fortunate. While living near New York, he was taken on by the Willard Gallery and found in Marian Willard Johnson one of that steadily diminishing group of dealers who cares at least as much about the artist's welfare as about his sales. Mrs. Johnson, as the eastern representative of Mark Tobey and Morris Graves, had already developed a special feeling for the flavor of the Northwest. At first she limited McCracken's participation to group shows, but since 1960 has mounted one-man exhibitions whenever he has been ready for them.

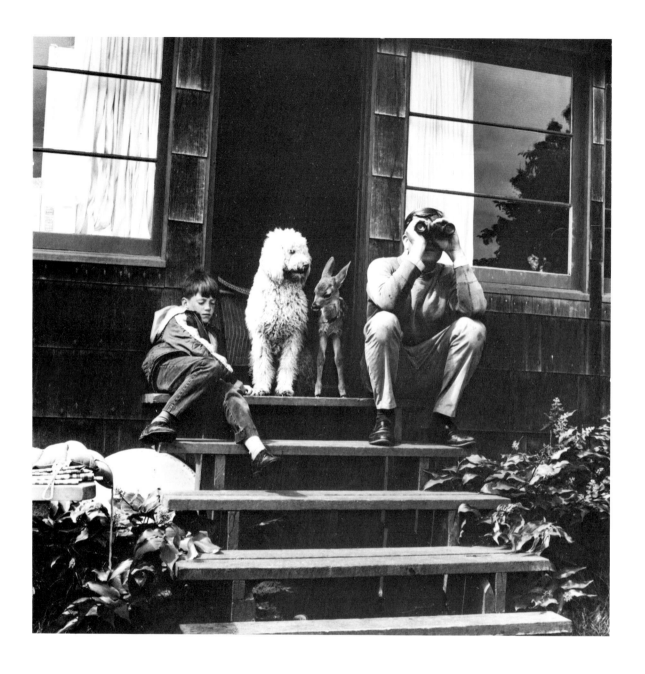

Northwest collectors were not slow to realize that a sculptor of special quality had appeared in their midst. Together with a perceptive New York following they saw to it that as long as he produced the nature-based works to which they had become accustomed, his pieces went readily into their collections. The Seattle Art Museum for its part led the way among institutional patrons, while public commissions began to come in with fair regularity.

When in 1963 an annual "Governor's Medal" was created for an outstanding artist of Washington state as nominated by leading critics, there was general approval when the first award went to McCracken.

THE SCULPTURE

Early in McCracken's student days he had begun to work on some of the basic nature themes which would characterize most of his art at maturity. Even at that formative stage hints of a personal style began to emerge, although inevitably at the outset there were influences from other artists. *Rain Forest Forms* of 1953, for instance, is a mobile that is patently a pastiche of Calder. Yet the title is already significantly indigenous, as is that of *Heron* of the same period.

It required only a few months more for both theme and style to become personal. *Killer Whale* (see page 41) of 1953 is a northwest subject carved in rhythms distinctively his in the medium of red cedar, which was to become his favorite. Nevertheless, by the standards of his later sculpture it is a superficial work, decorative but without the interior vitality or the multiple meanings of later pieces.

The breakthrough came with *Black Mask* (p. 42) late in 1953. Here an extremely simple form has somehow become a haunting psychic image, one that could not have issued from any other artist. Charged with a dark inner force, the work operates on more than one content level; it is redolent of the forest while at the same time hinting at the human visage. Allusion to the mask form brings in a further load of associational overtones.

The works of the next two years continue on this deeper level but bear traces suggesting, in such carvings as *Snowy Owl* (p. 43), *Resting Bird*, and *Standing Bird*, that McCracken was still under the influence of Morris Graves, the Washington painter of birds for whom he has always had a profound admiration.

Georges Braque once exclaimed, "A work of art that doesn't astonish! What is that?" McCracken is prolific with surprises. True, there are certain subjects such as families of owls which recur from time to time in rich rather than surprising variations; but from 1956 onwards works of often startling originality, for which there are no precedents, appear regularly.

One of these is *Visored Warrior* (p. 44) of that year. It is the first of several sculptures on themes in which violence is either directly alluded to or else implicit. It is also the first of many involving the use of two or more highly disparate materials. The strangeness of the work derives from the smooth elegance and awkward stance of the piece in conflict with its martial theme.

The following year *Piping Rabbit* (p. 46) came as another surprise. The McCracken household's reverence for living things has never prevented its members from hugely enjoying animals as comics, and McCracken himself has a keen sense of the funny. This fey little joker cast in pewter is a blend of animal humor and folk poetry for which nothing in his previous oeuvre has prepared us. It is a vein which will surface again.

A few months later *Caged Bird* (p. 50) introduced a claustrophobic theme with anthropomorphic overtones. The onlooker may read into it whichever of several possible meanings he prefers: man's sadism toward wild life, contemporary man strapped in a technological straightjacket, or, as one viewer suggested, "the spirit of man imprisoned by pressures of social custom and hypocrisy." In devising this image the artist had no specific program, nor could he have had since the symbolism is too broad to be confined to a single idea.

With *War Bird* (p. 60) of 1960, twentieth-century violence is summed up in an ikon of awesome brutality and power, a presence that mixes majesty with menace. Gentle and compassionate though McCracken is, he has his own reserves of power and looks with a cool eye at violence in both the human and animal world. Himself a hunter who shoots only for food and who, like an Indian, religiously releases in deep respect the first salmon caught every year, he knows perhaps better than the city dweller how much of life is involved with the interaction of predators and their victims. Yet he remains puzzled by the sheer quantity of violence in the modern world. *War Bird* summed up at this stage of his growth what he was later to define as "the elements of life and the human condition which I find most perplexing and arbitrary." At the same time his aim is "not to judge but to understand something of our mystery,

not to condemn it." But first and foremost he makes sure that esthetics prevail over the temptation to become didactic. "If I can't put the critical comment into an esthetically adequate form, I don't make the comment."

The varied materials which go to make up *War Bird* are far from being merely an assortment of conveniently contrasting textures in a design. Their choice, as in all the artist's work, has been dictated by emotional imperatives. As a symbol of menace, for example, the use of a circular saw blade is a flash of pure poetry, however devastating the implications.

Related to *War Bird* is *Saint Sebastian* (p. 57) of a year earlier. Here the title, which of course refers to the Christian convert who was executed with Roman arrows, makes the human relevance explicit. If *War Bird* is a prime aggressor symbol, then the implacable finality with which the arrows strike home in *Saint Sebastian* makes that image an obvious symbol of the sinned against.

Musings on the lot of living things produced *Out of Darkness* (p. 55), a work which reminds us of the ancient Anglo-Saxon parable likening human life to the condition of a bird which emerges from the night into a lighted hall, only to pass quickly out into the oblivion of the dark.

Concomitant with images of savagery of these years there runs a parallel stream of carvings on themes of tenderness and wonder. *Owl Home* (p. 53), for instance, is one of a group composed on a specific subject. "I use owls here," McCracken remarked, "as in the past, to express the serenity and intimacy of a family in its natural home." *Winter Bird* (p. 62) and *Mother and Young* (p. 63) of the following year continue the theme.

Both plant life and inanimate nature provide material at this time, as is clear from such titles as *Spring Blossom* (p. 54), *Passage to the Island* (p. 77), and *River Rock* (p. 78). The last is a carving in cedar of the finest subtlety. Under the sinuous flow of river water a submerged rock is sensed rather than seen. The movement of curves on the surface has a mystery and tenderness that defy technical analysis.

After the humor of *Piping Rabbit* there is an absence of light heartedness until the appearance of *Ocean Sorcerer* (p. 67). Once again the way materials are handled is a source of surprise. Essentially they are the same in *War Bird*—metal, wood, leather—but whereas in the latter all connotations are sinister, here they evoke only a sprightly wonder, a sense of magic and a make-believe awe.

In 1964 came the first hint of a radical departure that was to take McCracken's art into strange territory for several years. In terms of form *New Machine* (p. 84) is a traditional sculpture in a traditional kind of abstract shape. It is the incorporation of machine parts that signals a move away from organic life to a concern with advanced technology and its impact on post-industrial civilization.

Strangely, this harbinger of things to come did not produce a sequel until the appearance of *Insect Revolt* (p. 87) two years later. In the latter piece an insurrection in the ant world is depicted through an audacious mix of radio parts, gun barrels, tubes, wires and shattered glass. Thus the focus has shifted from the forest life of Guemes to the broad arena of international relations. Clearly, vibrations from the world scene were being sensed with the same force on Guemes as in the cold-water artist flats of New York and London.

While *Insect Revolt* was expressing McCracken's concern over the way matters were going in the outer world, other sculptures of the period testify to his continuing love affair with the warmer little cosmos of Guemes. *Mother and Young, Human Heart* (pp. 63, 88), and *Poems* are typical titles of this phase.

At this juncture there came an opportunity to give public expression to his attachment to the Skagit area. Gus Hensler, a citizen of Anacortes, died leaving a will in which he set aside a sum for a public project in gratitude, as he expressed it, for a lifetime of happiness in that city. McCracken was commissioned to create Hensler's monument. The site chosen was the summit of nearby Mount Erie, and there he erected the bronze *Mountain Bird* (p. 89) on a tall shaft of concrete. The work is one of the most successful of his public commissions, partly because of its sensitive adaptation to the site and partly because the medium lends itself to greater subtlety of line and surface than was possible in the stone and cast concrete of previous commissions.

The year that followed was an altogether different matter. The moral problems of the war in Vietnam had become unbearably acute. American cities had been in flames, and the Kennedy-King killings had left a residue of horror in everyone's mind. Thus bullets form the central fact of *Healed Up Sky*, while *I Saw* (pp. 90, 91) brought back the circular saw blade of *War Bird* to create an icily ominous image of ripping and cut-

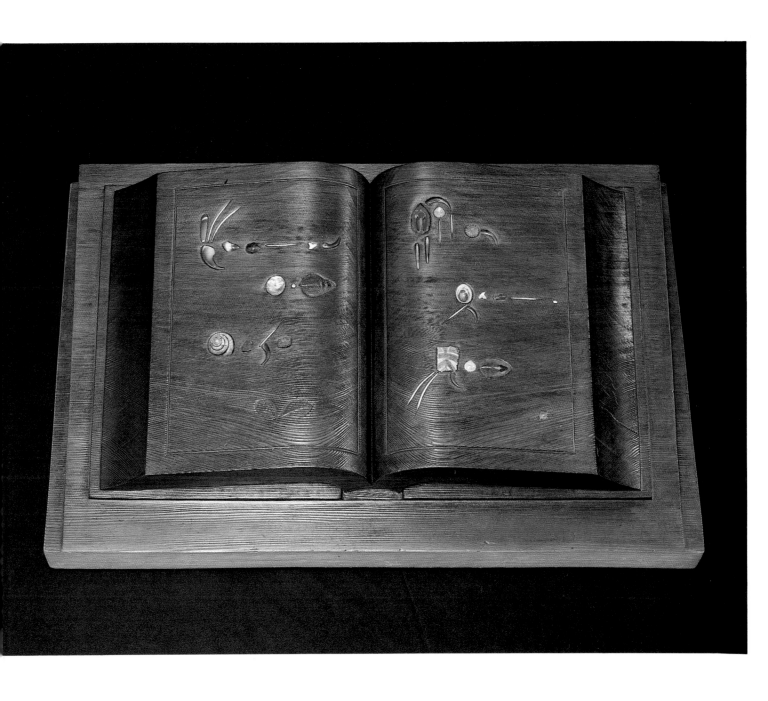

POEMS 1966 Mixed Media L. 32″
Collection: Private

The "book" illustrated here testifies to the fact that the now somewhat
hackneyed medium of assemblage can still be lifted, through emotion
and insight, into the realms of poetry. The emotions are of course those
of reverence for the exquisiteness of natural forms and delight in their
beauty. Limpets, porcupine quills, bear claws, a snail shell, a leaf, a
walnut shell, and other diverse shapes are somehow welded into a
unity. They suggest a kind of calligraphy whose symbols discourse on
the mysteries of nature.

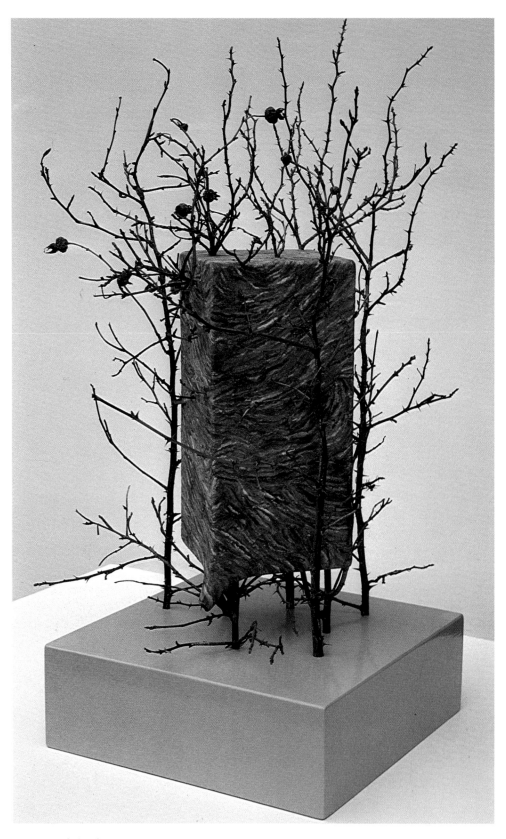

HORNET'S NEST 1969 Hornet paper and wild rose bushes Ht. 2′2″
Collection: Anne Gould Hauberg

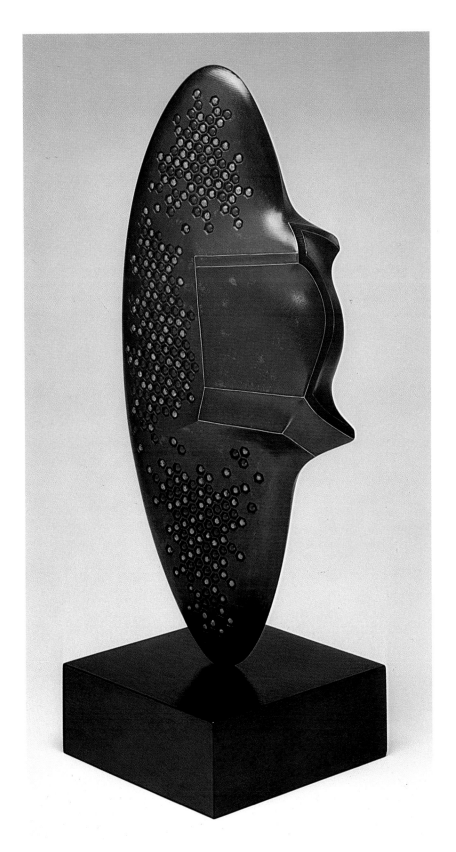

WILD HONEY 1970 Cedar, gold wire, and gold leaf Ht. 21¼″
Collection: Helen and Marshall Hatch

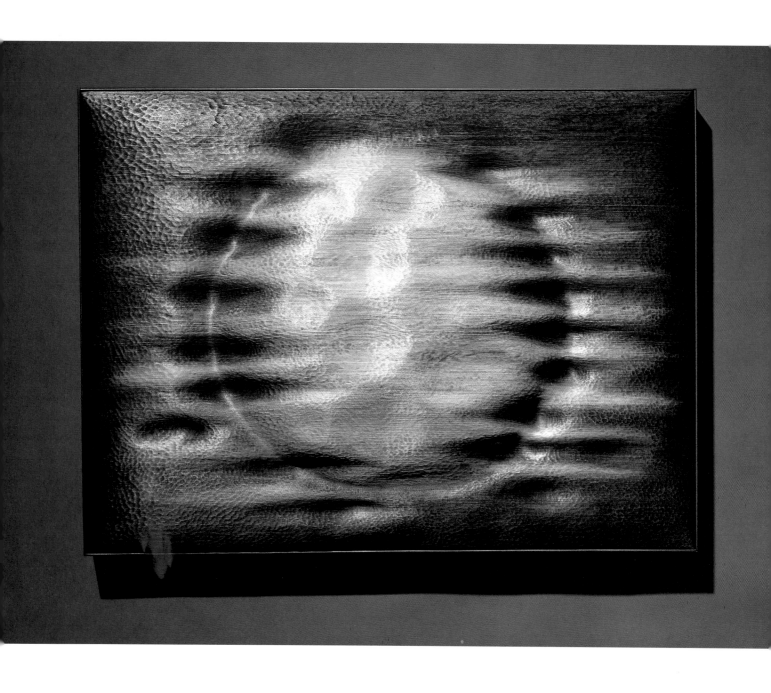

MOON 1971 Cedar L. 35½"
Collection: Anne McCracken

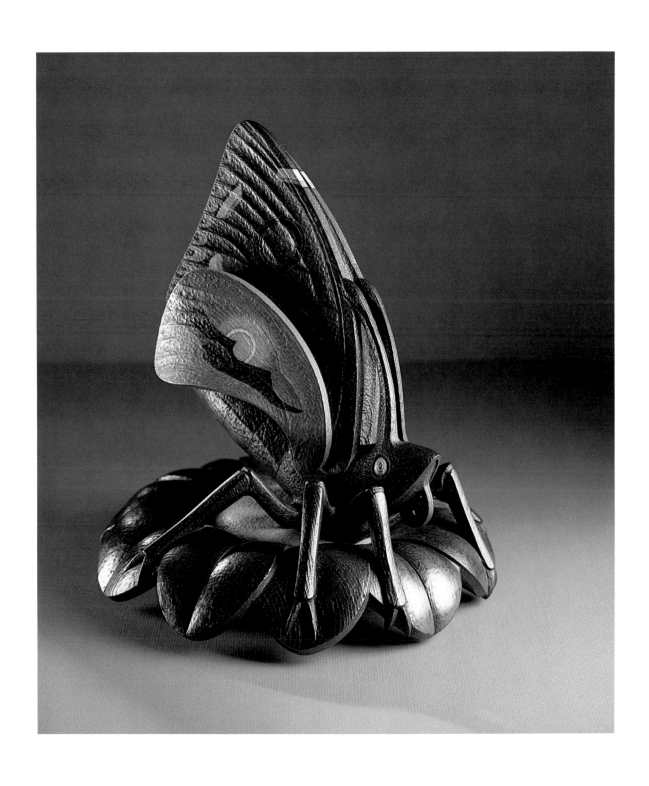

SATYRID 1974 Polychromed cedar Ht. 13½"
Collection: Dr. and Mrs. Jack L. Reid

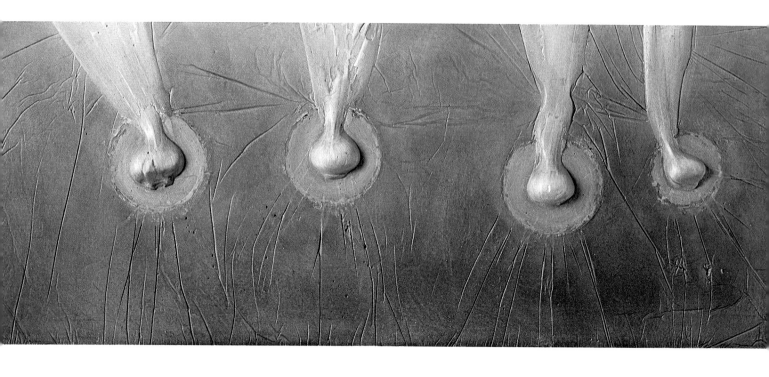

DREAMING TULIPS 1975 Fresco L. 29¾"
Collection: Anne Gould Hauberg

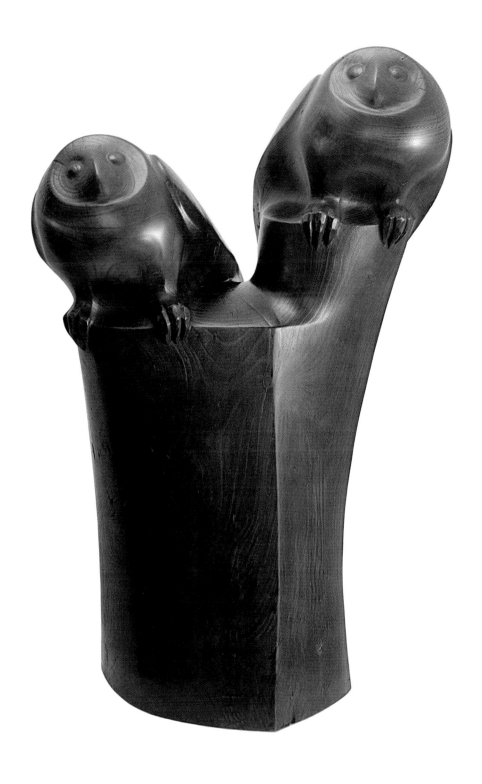

TWO OWLS 1978 Plum wood Ht. 20⅛″
Collection: Helen and Marshall Hatch

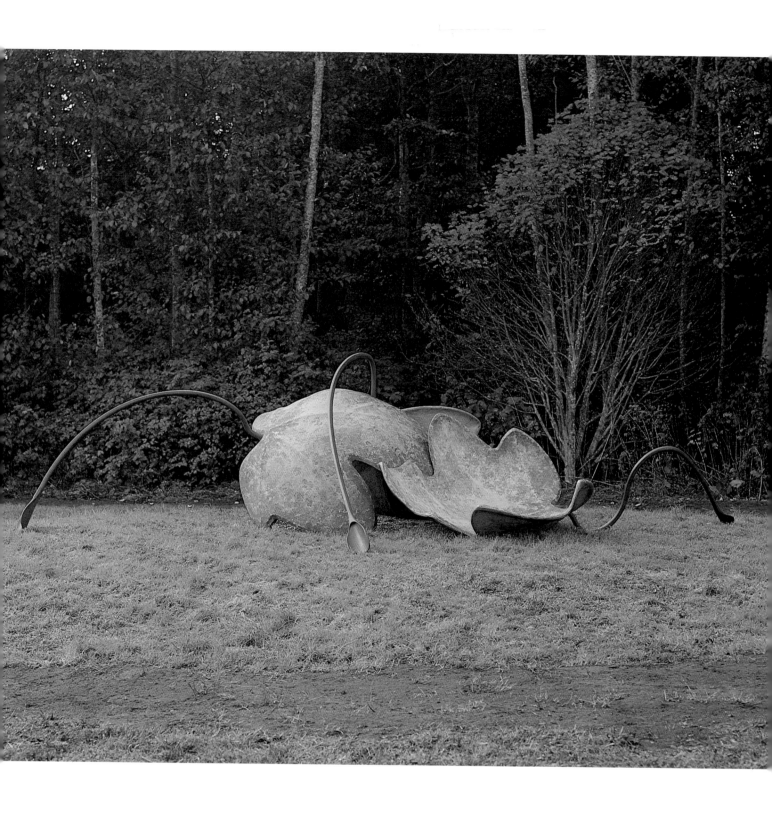

AUTUMN LEAVES 1979 Fiberglass, concrete, and steel L. 21'9"
Collection: Skagit County Park, Guemes Island

ting. Although the overtones of *Burning Through* (p. 92) are free of dread, they do relate to power and aggression. It is *Lights Out* (p. 93), however, that provides the most blood-freezing image of them all, a final summing up of the artist's preoccupation with gun-saturated evil.

Only one piece of this year carried on the nature theme, and that was *I Love You Tree* (p. 94). Even this witty transfigured saw, with its love-aggression aura, has a background of violence.

Each of these sculptures is memorable for the originality of its concept; but arresting though the themes are in themselves, it is in the underlying esthetics that the most radical departures occur. The new works, in fact, take us quite a few steps in the direction of conceptual art. In *I Saw* the plastic elements are so simple and so few that by themselves they do not create a statement of the fullest complexity. It is only when the onlooker's mind introduces an extra dimension by adding to the piece all the associations accumulated over a lifetime with dangerous saws that the work becomes complete.

Likewise in *Lights Out* the tension is more conceptual than visual. The five light bulbs are sited at wholly regular intervals. They sit precisely in the middle of their box. Such simple bilateral symmetry eliminates the possibility of visual tension. It requires the addition of an engaged mind to size up the situation and reach the conclusion that, in the words of a New York

critic, "a ghostly sniper is at work." At once the scene becomes charged with psychological tension as the observer seems to await the final shot.

Heavy with menace though these images are, the terrible is not without its seductive beauty. In his introduction to the catalogue accompanying his exhibition at the Willard Gallery in New York in 1968, in which this work was first shown, McCracken specifically alludes to this element: "In several pieces bullet holes are used as a form language expressive of violence—yet in themselves are beautiful. Like crystal stars, cold and timeless they appear. It is this ambivalence which makes them most useful in a form vocabulary."

Referring generally to the works of this period he remarked, "I have taken every means to make these pieces as articulate as possible in the formal sense. No risks were taken that I could avoid in making the form language clear and unmistakable . . . the risks I took were the large conceptual ones where the risks were worth taking." He also drew attention to the relationship of several works to the time factor, to "the translation of the *instant of occurrence* into a constructed physical presence. The instant someone tells you they love you for the first time; the instant before an automobile accident; the instant you see your first-born child; the instant you realize you are being shot at."

As the artist remarked at the time of that exhibition, "This is a dangerous group of works to show in terms of safe marketplace procedure. One is expected to carry on and extend what one does well, but the imagination is a siren—it draws one onward and one must hazard going on the rocks." His apprehensions were only too well founded. The show was greeted by New York critics with ready comprehension, but to many of the regular patrons who had come to know and love his nature themes this new vein was bewildering. Similarly, when most of the same works appeared at Seattle's Richard White Gallery in December of 1968 in a joint display with the painter Leo Kenney, critical acclaim and popular puzzlement went hand in hand.

Since compromise and a return to the kind of sculpture that would sell was out of the question, and since scarce sales had put him in a position where he was about to turn commercial fisherman to survive, it was fortunate that there would be only a few more works in the new vein, such as *Limoges* (p. 100) and *Silver Bow* (p. 97). Before long it became clear that he had exhausted for the time being the things he had to say in response to the *Zeitgeist* of the sixties. Only *Sampler* animadverted, and this time humorously, on the way the world seemed to be going.

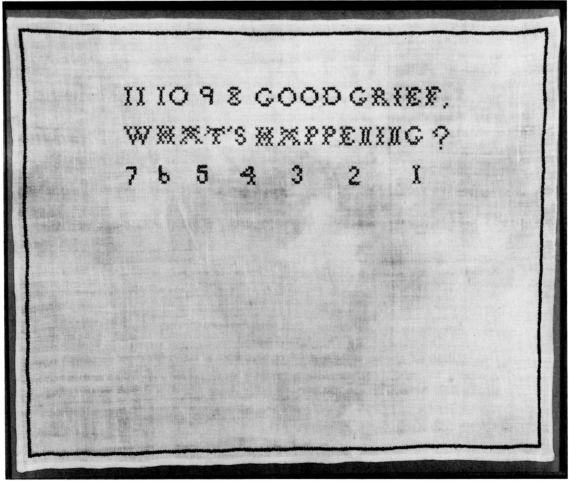

SAMPLER 1969 Needlepoint on linen Ht. 19″
Collection: Anne McCracken

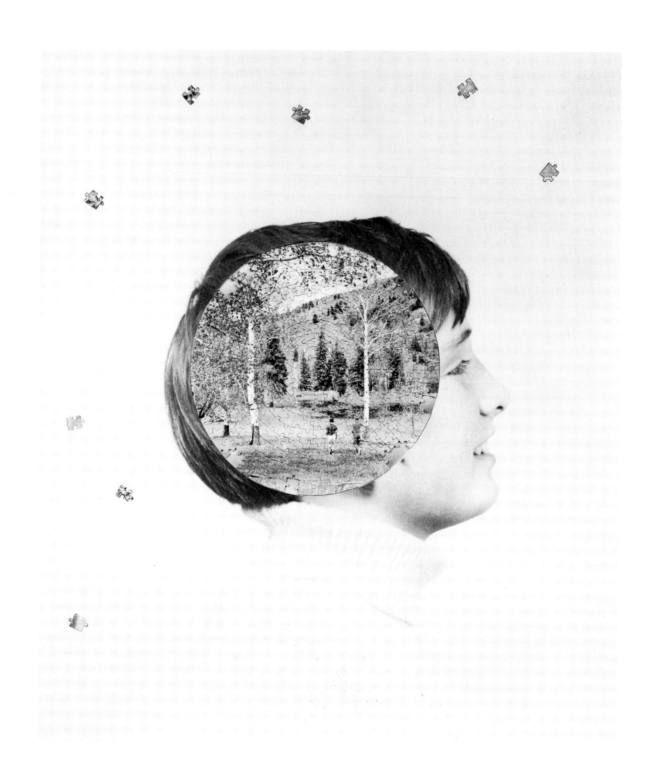

PORTRAIT OF TIM 1969 Photograph and jig-saw puzzle Ht. 38¼″
Collection: Anne McCracken

His introduction in the catalogue for the next show at the Willard, which took place in February of 1970, made it clear that he was fully conscious of the changes that were now taking place in his approach. "The major concern of this new work," he wrote, "has not been with violence or immediate peak experience as it has been in the recent past, although trace elements will be found here, but rather the bringing together of forms and ideas, drawn from the past both dim and recent, stripped of their associational baggage, and joined in a new range of media and an expanded frame of reference. Forms from nature have been reintroduced not as they were first in the work of 1955–67, as interpretive, but directly in the medium of flowers, hornet paper, bark, birds' nests and wild roses. They have been brought together with other forms and materials that were chosen in part for their qualities of conflict and alienation, which was necessary, but with deeper regard for the need to recognize their underlying independence and ultimate compatibility, and to bring them together in that spirit."

Examples from this period are *Hornets' Nest* (p. 26), *173 Parkside* (p. 96), and *Aerial Nest*, all of them in a sense nature themes. *Portrait Of Tim* is indeed a nature poem, for his eldest son was at that time having a problem keeping his day-dreaming thoughts away from his island paradise as he struggled through uncongenial lessons at the Anacortes high school.

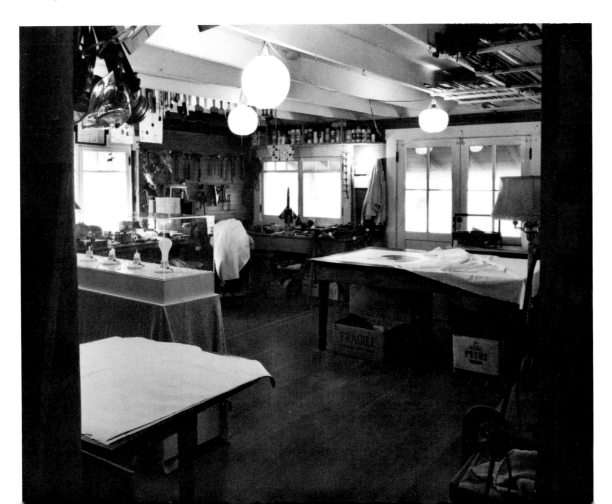

At this juncture the offer of a large commission for a garden sculpture arrived at a moment that was esthetically as well as financially crucial, for McCracken was beginning to long once more for the feel of a chisel on cedar. The theme he selected was that of a thrusting spring shoot surmounted by a nascent bud. From the seaching out of a cedar log in the hills thirty miles away to its final erection as a sixteen-foot sculpture, there elapsed an interval of more than a year. *Spring* (p. 103), as he decided to call it, turned out to be the culminating achievement in two decades of carving. A paean to the principle of growth, it is a work of slowly moving volumes ascending in rich complexity to the bud as it strains to burst into flower. After the tense involvements with destruction and violence, *Spring* came as a positive release and a means of affirmation.

The act of working again in an organic medium unleashed a flood of new images. *Wild Honey* (p. 27) introduces exquisite and immaculate planar twists and warps in its homage to insect architecture. The resolution of thrust and counterthrust into perfect poise seems to make it a contemporary equivalent of classical contrapposto. Perhaps the most mysterious image of all emerged in *Moon* (p. 28), a work reminiscent of *River Rock* in form but totally different in spirit. Through some wizardry of carving and staining McCracken has contrived to create surfaces whose position in space seems to fluctuate. It is as though the moon were being glimpsed through moving waters or the heat waves of a summer night.

In 1975 a new preoccupation with certain qualities of light led him in a different direction. While continuing to work in wood, he began to experiment with the possibilities of fresco. He wanted to give form to a special feeling about light in a spiritual sense, the light which he has described as "the sacred envelope which infuses, radiates . . . the light of the imagination which surrounds the most beautiful things."

In the past he had either scorched his wood surfaces with a blow torch or stained them with dark umbers. The soft, barely perceptible inner glow which resulted was evocative and satisfying, but it was not the kind of radiance he had been experiencing in recent months.

Only the pristine reflectivity of burnished plaster, it seems, could create the ethereal effects he was after. To achieve such ends he began to use whichever of three fresco techniques answered his needs at a given moment. There was what the mediaeval Italians called *buon fresco* in which pure powder pigments mixed only with water were applied to a wet plaster surface. Then there was *fresco secco* in which the pigments, held together by a medium such as casein, were applied to a

dried plaster surface. Finally, there was integral color in which the pigments were stirred into the body of the wet plaster so that the color, instead of lying merely on the surface, permeated the whole mixture.

Thus in *Dreaming Tulips* (p. 30) light seems to emanate from within the subterranean bulbs in a way that would have been impossible with stained wood. Perhaps *Eagle's Path* best epitomises the kind of luminosity he was able to achieve through fresco. Against a cerulean sky of utmost purity a straight gouged line suggests power, predatory verve, and stark speed. It is a poet's rendering of the esthetics of infinite space and overriding force. In *Green Wing Shield* and *Red Dwarf* he introduces orbs of Jungian, mandala-like potency, the first in an elegiac mood and the second with an enormous but contained feeling of cosmic powers.

The next foray into a new field produced a group of small assemblages made up from odds and ends lying around the studio. McCracken has described (see page 120) how after the prolonged tension of making a major commissioned work he turned lightheartedly for relief to these strange little representations of personages placed in various enigmatic contexts. But what began as humor sometimes drew him beneath the surface to regions where the feelings were bitter-sweet and even faintly disturbing. Part of the key to the pull McCracken's sculpture exerts on the onlooker is the exceptional ease with which, without consciously trying, he reaches down to the deeper levels of his subconscious mind.

This group was followed by still another push into fresh territory. He who had not painted seriously since his student days, now began working on oil landscapes and seascapes. A couple of years previous to this he had done a series of small drawings in colored pencils depicting haloed vegetation and roiled waters. The subjects were much the same in these oils with the exception that the medium and scale allowed him to achieve a more pulsating radiance and a greater wealth of visual incident.

During this last branch-line excursion he had been steadily at work on new commissions. For the Whatcom County Museum in Bellingham he produced a brooding heron in bronze. Then came a powerful bird of prey in cedar for the Bell Telephone Company. Next was a major work, *Autumn Leaves* (p. 32), which was designed for a children's playground on Guemes. It comprises three fallen leaves which interact in contrapuntal rhythms of considerable complexity. The lightness with which the stalks and leaves seem to lie on the ground gives no hint of the concealed techniques by which the piece is impregnably

anchored to the soil and at the same time made accident-proof to the clamberings and investigations which its design invites.

By this time McCracken, like Henry Moore, had reached a point where assistants were necessary. Again his luck held in finding aides like Michael Gwost who were masters of several media and adept at sensing his every need.

In his early days as an emerging professional he had made one or two pieces based on the human figure, but in general the human form had been absent from his oeuvre as an explicit shape and had been sensed only indirectly through bird and animal surrogates. Now, while he was working on *Fallen Leaves*, a patron of a monastery asked him to do two figures representing Saint Benedict and Saint Scolastica. The result was a pair carved from cedar whose simple nobility and quiet purity of spirit serve as a reminder that religious sculpture, even when made by an artist without doctrinal affiliations, is still possible in this secular age.

Enough has probably been said in this introduction to make it clear that in spite of the surprisingly various forms his imagination has given rise to, McCracken is uninterested in novelty and change for their own sakes. He has merely followed his intuition in whatever direction it has taken him. Nor has it bothered him that his evolution as a sculptor has usually set him a short distance away from the mainstreams of art in America. The force with which his ideas have gripped him, and the passion he has experienced in realizing them, have left him, for all his natural humility, in no doubt as to the authenticity of his vision.

To those living sealed off from the natural environment in the great North American conurbations, his birds and animals often have little to say apart from their formal qualities. But to those whose sympathies embrace the totality of organic life his work has a compelling attraction; and among that growing body of people who live with an acute sense of values lost under the onrush of technology, his spirit-saturated pieces tend to evoke feelings of enchantment tinged with nostalgia.

In the visual arts it is *de rigueur* in some circles at the present time to maintain a cool and sophisticated distance from the esthetic construct. Whatever the validity of this approach, it could never be McCracken's. The warmth of his emotions and his delight in the visible world are unsuppressible. The same can be said of his sense of the pervading mystery of things. All this is the hardly surprising outcome of a life which has developed in exceptional harmony with the land, the sea, and the human community.

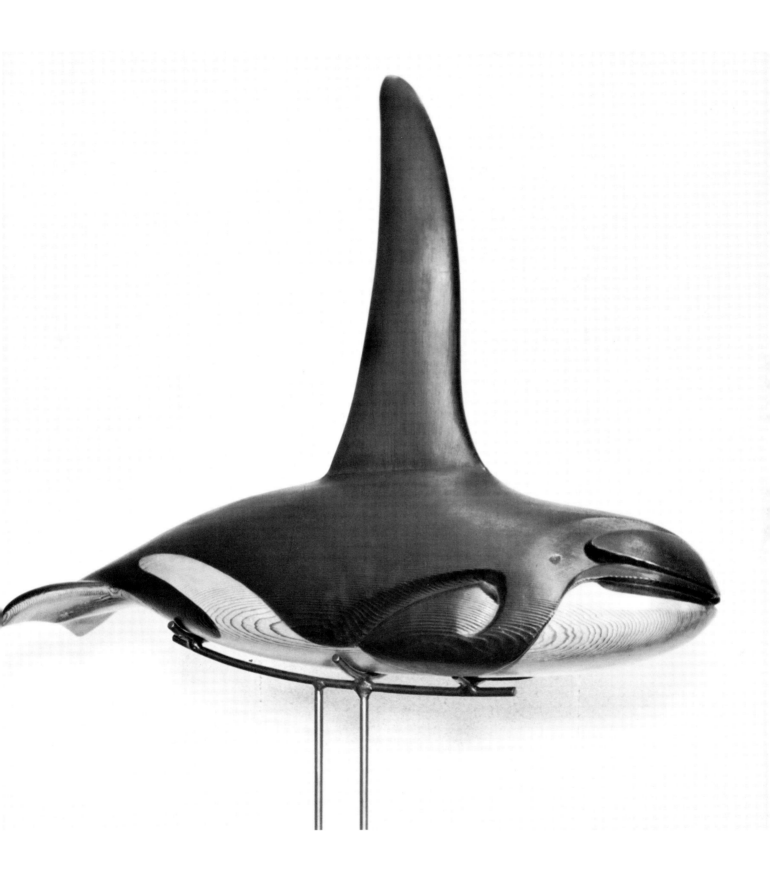

KILLER WHALE 1953 Red cedar L. 44″
Collection: Philip McCracken

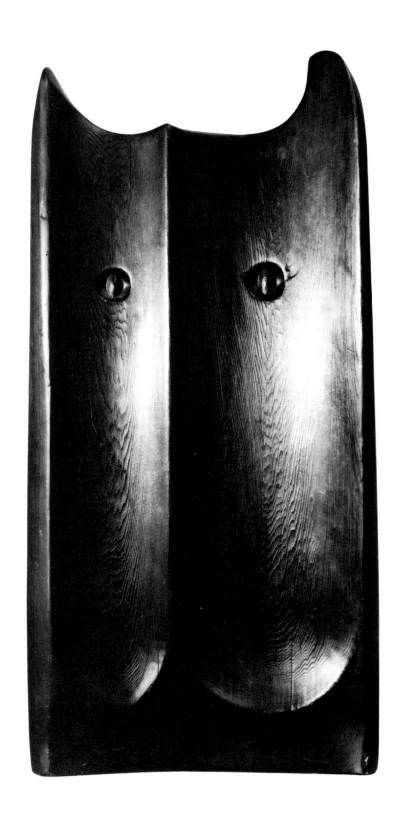

BLACK MASK 1953 Red cedar Ht. 28¼″
Collection: Mr. and Mrs. Langdon Simons

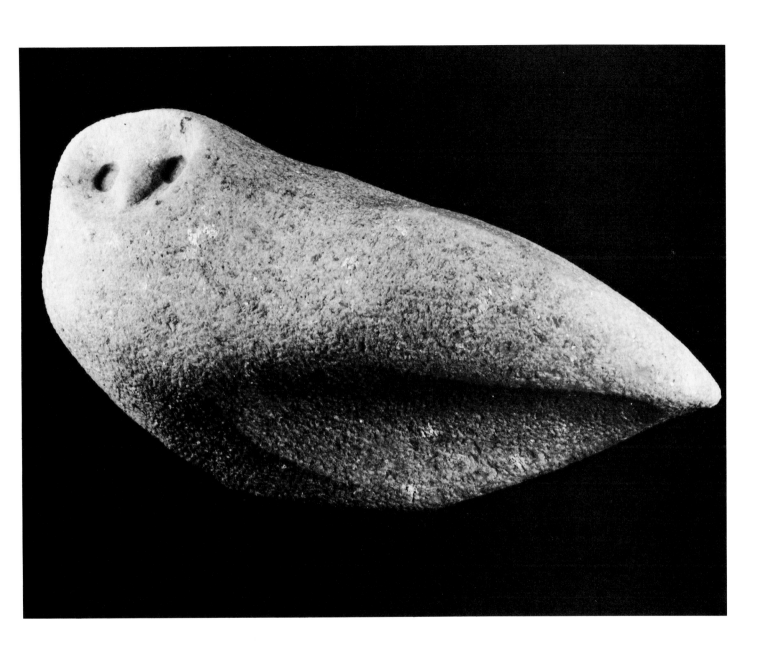

SNOWY OWL 1955 Westchester marble Ht. 9″
Collection: Seattle Art Museum,
Norman Davis Purchase Award and Northwest Annual Purchase Fund

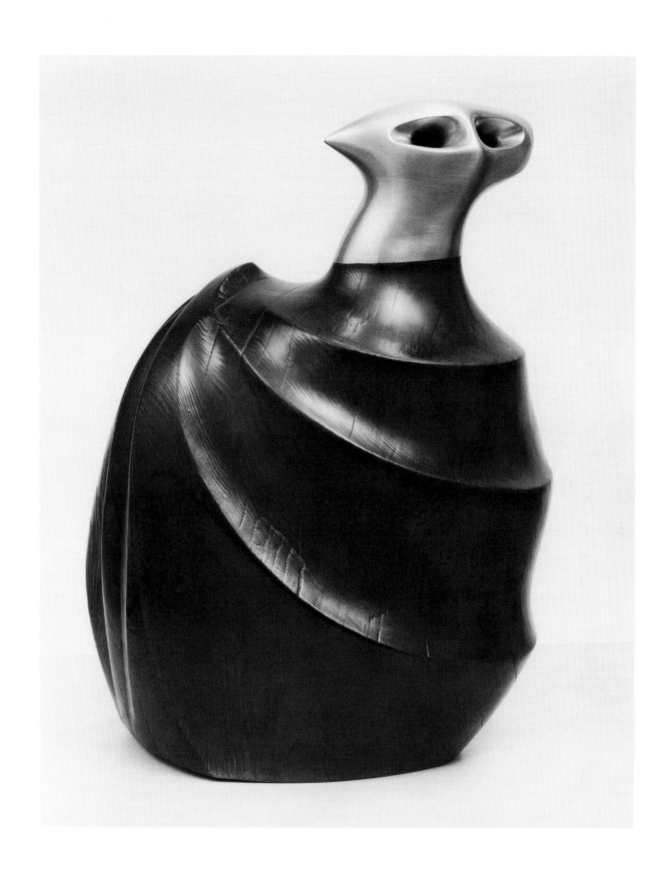

VISORED WARRIOR 1956 Cedar, pewter, and jasper Ht. 15″
Collection: Whitney Museum of American Art, New York

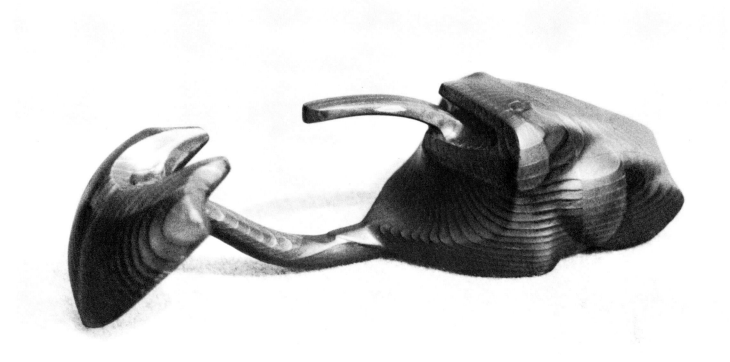

FROG 1956 Red cedar L. 12½″
Collection: Private

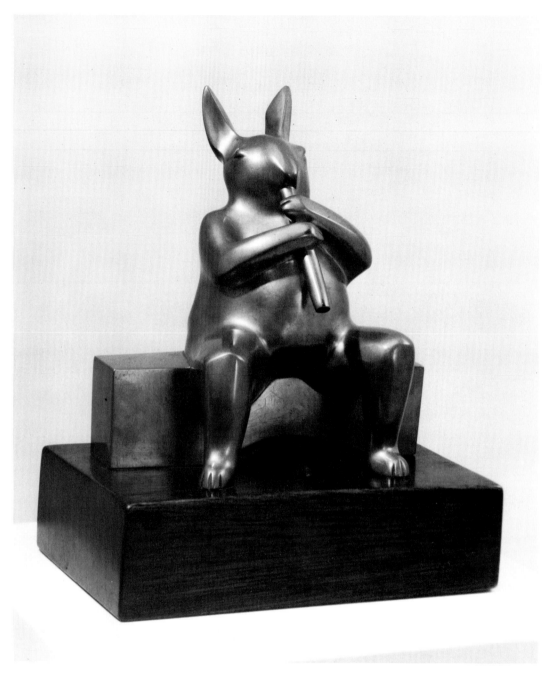

PIPING RABBIT 1957 Pewter Ht. 10½"
Collection: Private

From the twelfth-century Japanese Choju Giga scrolls to *Alice In Wonderland* and the cartoons of today, the world's arts have been leavened from time to time by comic beasts. Thus this rabbit takes his place in a venerable tradition. He is, however, clearly more than a workaday humorist. The tune he pipes has magic, bringing him closer to the fantasy world of *Alice* than to that of *Brer Rabbit*. It is the formal liberties which the artist has taken, such as the cubed arm and the arbitrarily flattened plane of the right leg, which by injecting an aura of the strange effectively remove this creature from the prosaic world.

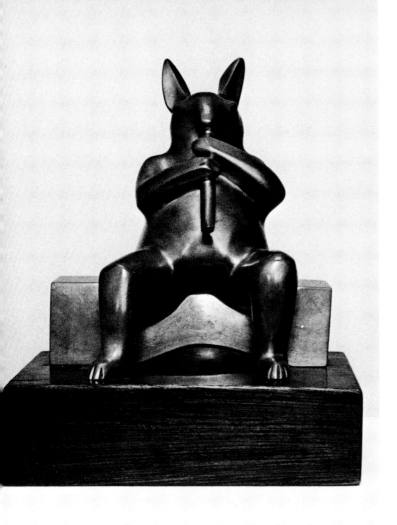

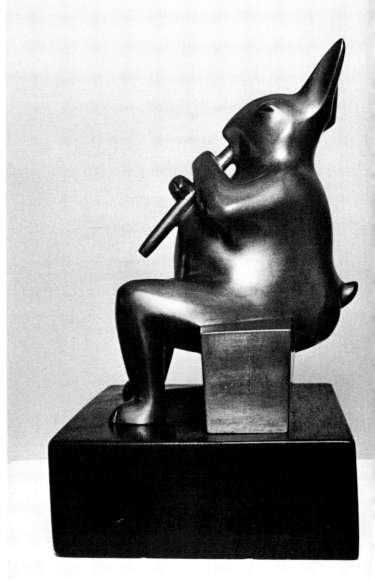

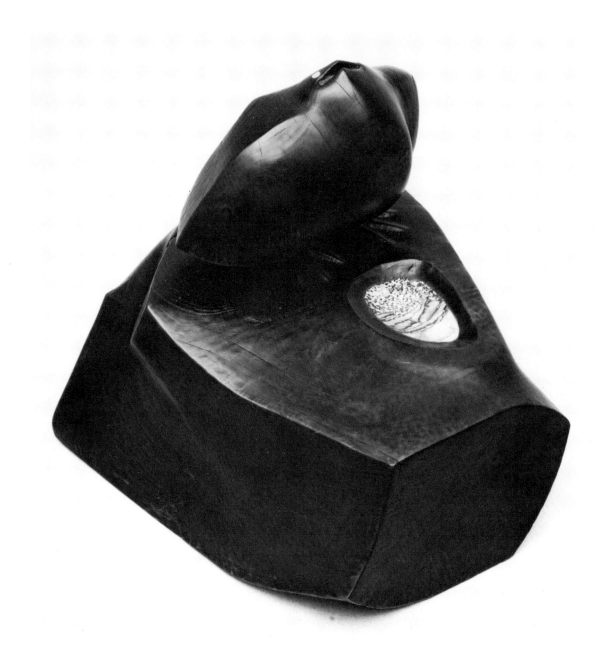

BIRD DRINKING MAGIC WATERS 1957 Juniper and abalone
shell 11″ × 11″ × 9″
Collection: Private

In 1968 McCracken wrote, "In a sense I feel as I once did as a child,
investigating the attic when no one was home—looking through all the
mysterious but somehow familiar things, yet realizing—with a certain
elation—the dangerous possibility of finding out what I shouldn't
know." Something like that may have been behind the creation of this
sculpture. Arcane mysteries seem to be involved as the bird sips from
the enchanted pool. An ecstatic experience is under way but the elixir,
to judge from the mood of the scene, has unlocked doors to the forbid-
den as well as to exaltations.

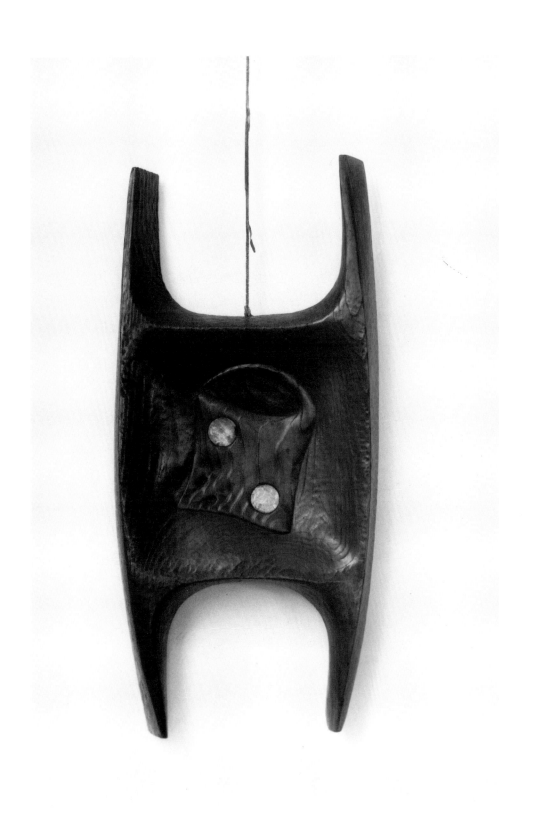

SKATE 1958 Red cedar and shell L. 16¾"
Collection: Anne McCracken

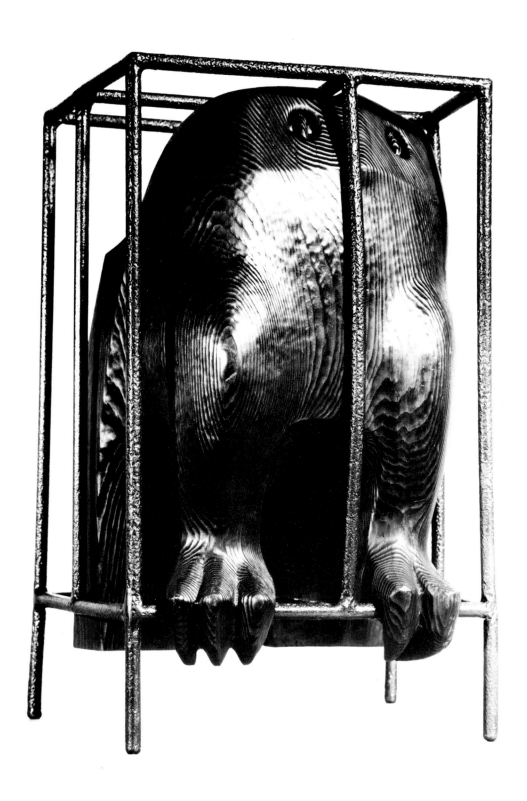

CAGED BIRD 1958 Red cedar and steel Ht. 16¼″
Collection: Seattle Center Playhouse

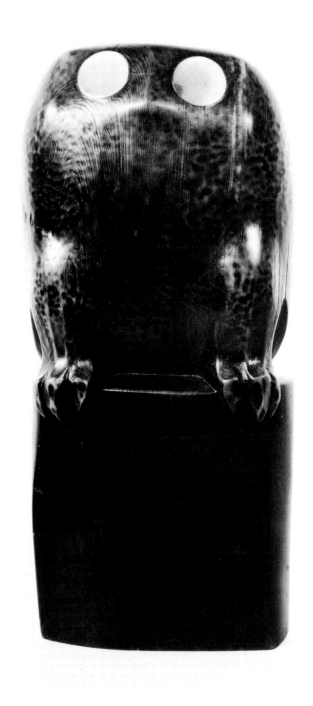

BLIND OWL 1958 Juniper and stone Ht. 9″
Collection: Whatcom Museum, Bellingham
Gift of Virginia Wright Foundation

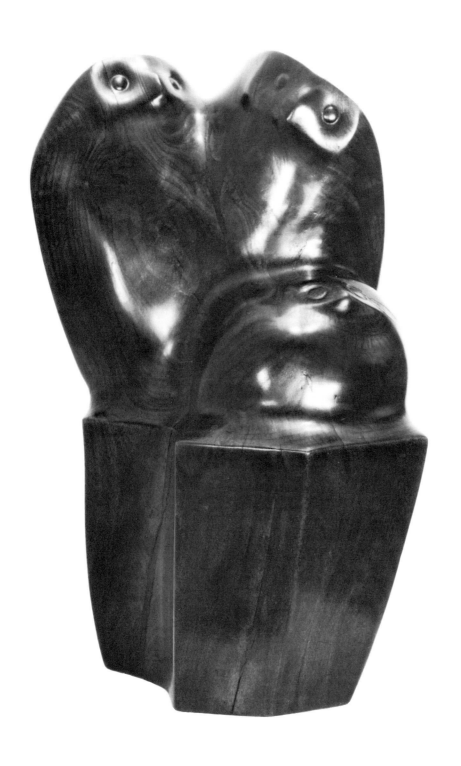

OWL FAMILY 1958 Plum wood Ht.13½″
Collection: Anne McCracken

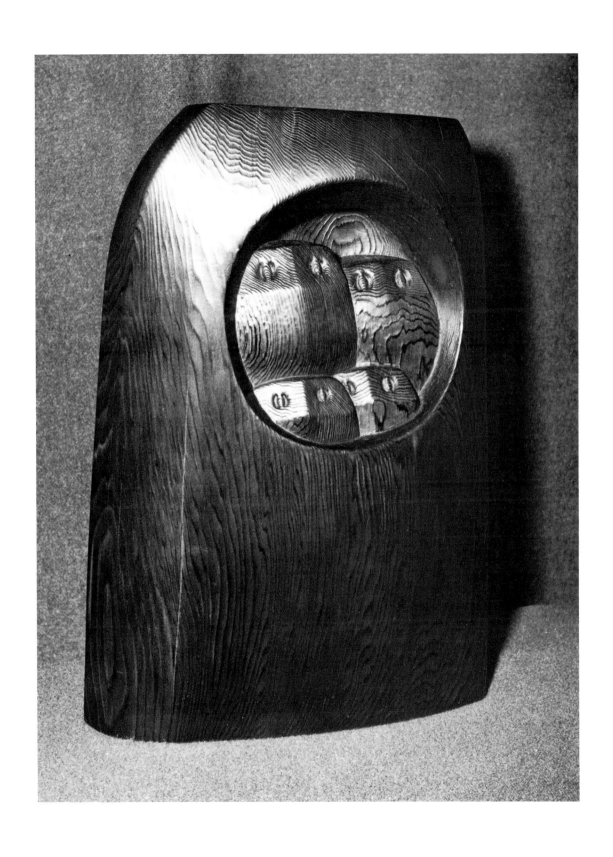

OWL HOME 1958 Red cedar Ht. 14″
Collection: Private

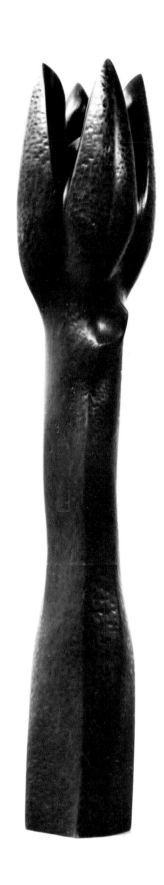

SPRING BLOSSOM 1959 Cedar Ht. 19″
Collection: Private

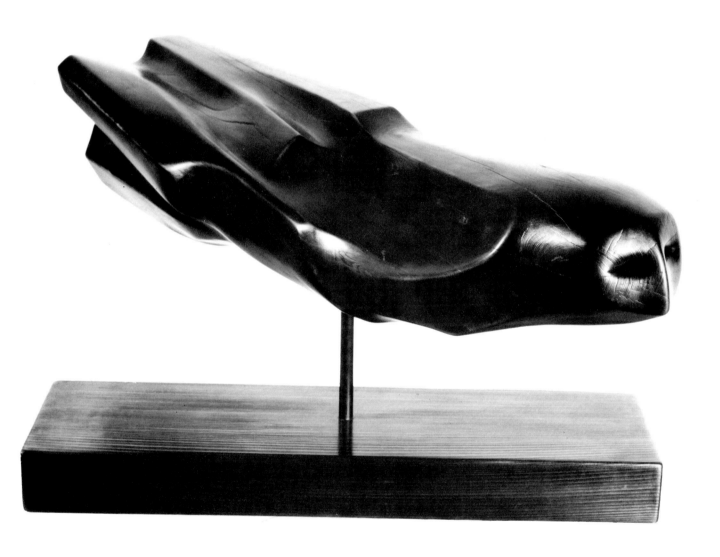

OUT OF DARKNESS 1959 Juniper L. 22½"
Collection: International Minerals and Chemicals Corp., Skokie,
Illinois

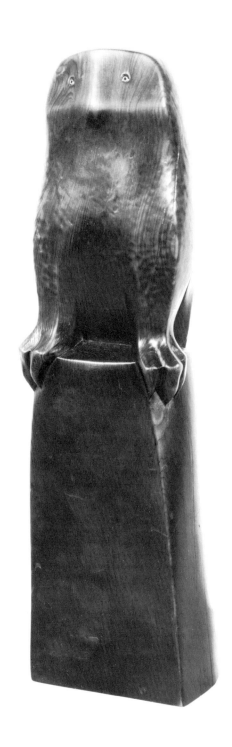

LITTLE RED EYED OWL 1959 Juniper Ht. 10¾″
Collection: Private

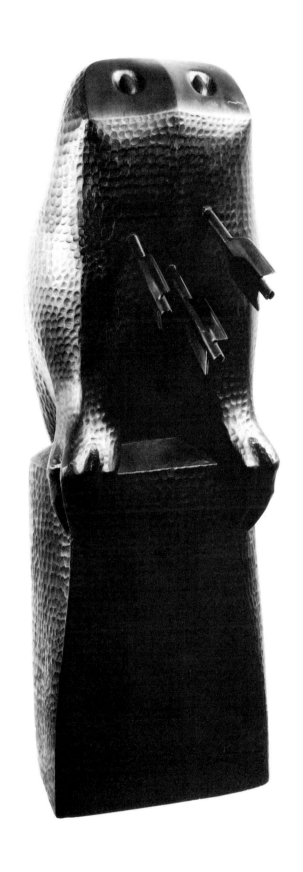

SAINT SEBASTIAN 1959 Red cedar and steel Ht. 25″
Collection: James McGrath

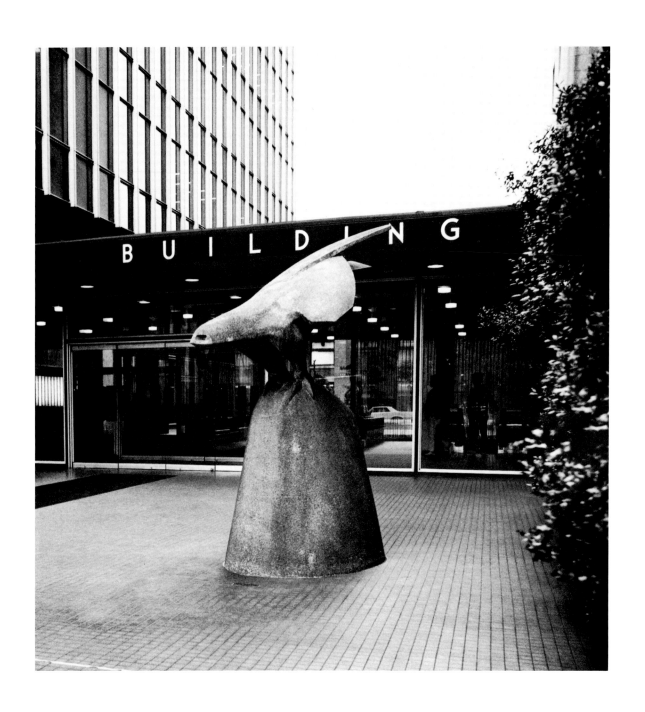

RESTLESS BIRD 1959 Cast stone Ht. 9′
Collection: Norton Building, Seattle

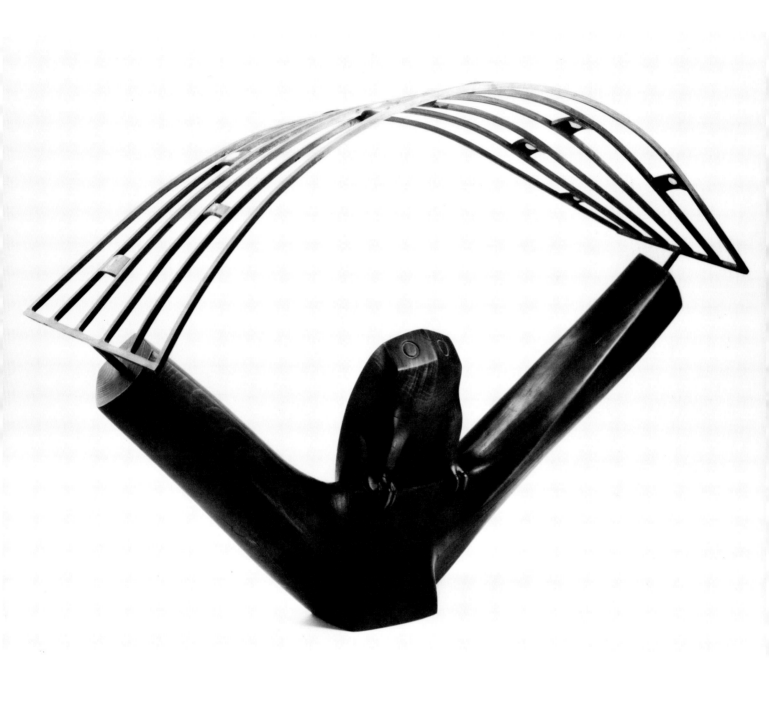

OWL UNDER STARRY SKY 1960 Juniper, brass, and agate Ht.
15½″
Collection: Art Complex Museum, Duxbury, Massachusetts

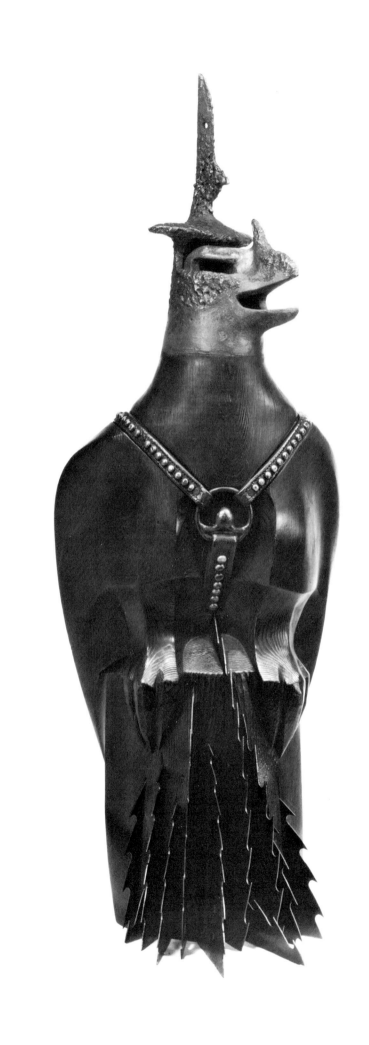

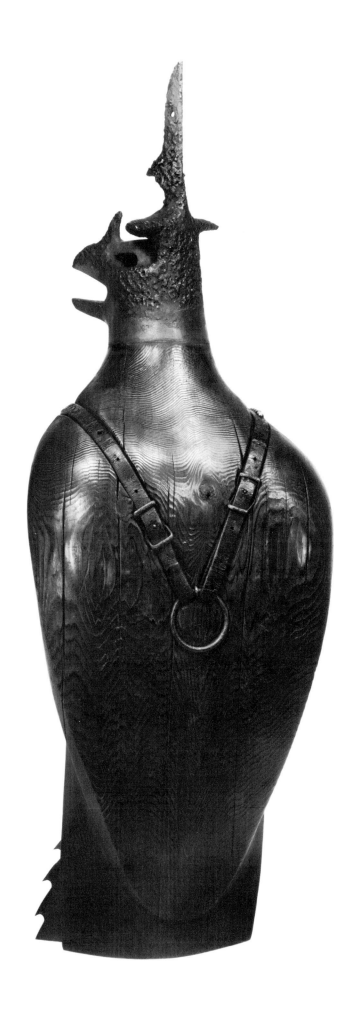

WAR BIRD 1960 Red cedar, steel, plastic
steel, leather, and copper Ht. 40½"
Collection: Seattle Art Museum, gift of the
Seattle Art Museum Guild

McCracken has always admired the clean, un-
equivocal violence of large birds of prey. "The
hawks are getting at my chickens," he once
wrote, "but I don't object: chickens are easy to
raise and I love to see the big birds coming in."
In this imposing image, however, the martial
leather straps, symbolical of the human mili-
tary, bring twentieth century man's less admi-
rable violence into the picture and thus ex-
pand the allusions into wider fields.

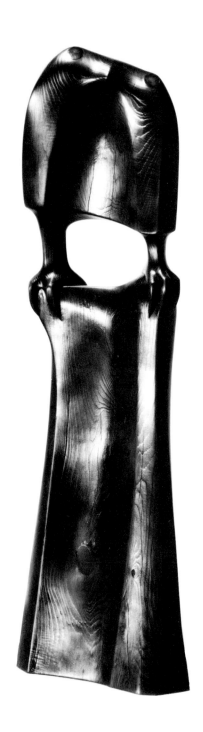

WINTER BIRD 1961 Juniper Ht. 20″
Collection: The St. Louis Art Museum, gift of Mr. and Mrs. Joseph Pulitzer, Jr.

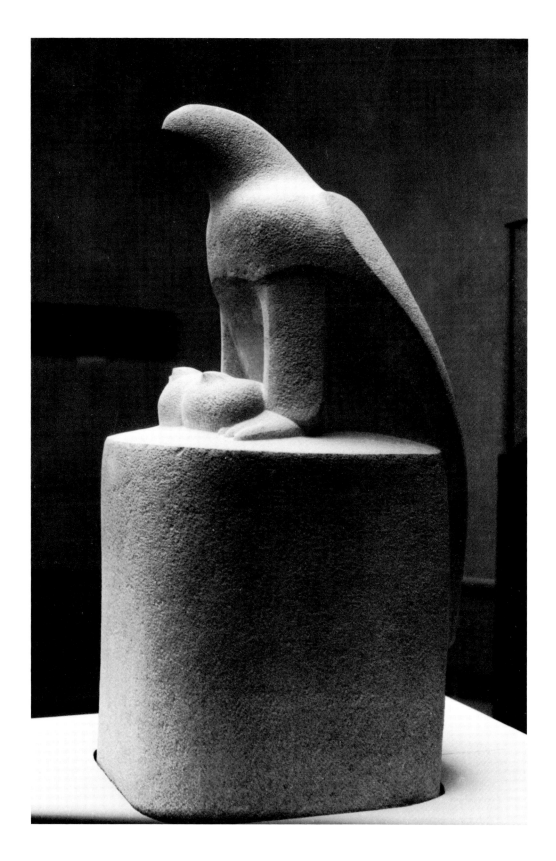

MOTHER AND YOUNG 1961 Sandstone Ht. 48″
Collection: Illinois Collection

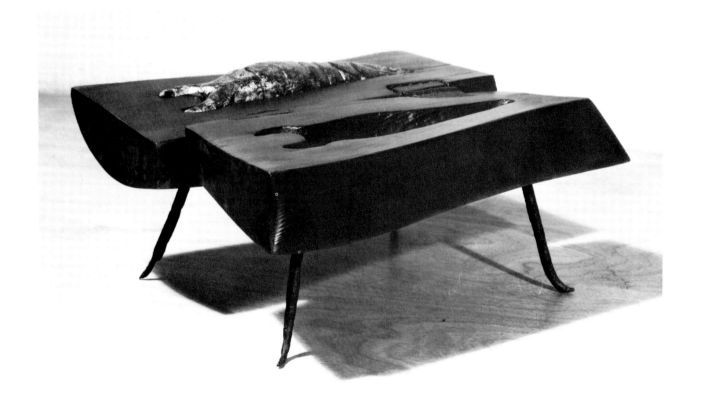

BOX FOR A LONG LOW JOURNEY 1961 Cedar, plastic steel,
and gold leaf L. 14″
Collection: Robert M. Sarkis

No better description could be found for this receptacle and its con-
tents than words the artist applied to some later works, which he
summed up as "a sample core taken from beneath intended meaning
and beyond available memory." Is the box a nurturing bed for some
magical larva? Or is it perhaps a mortuary form, a coffin bearing a
small soul toward the waters of Lethe? The image resists probing.

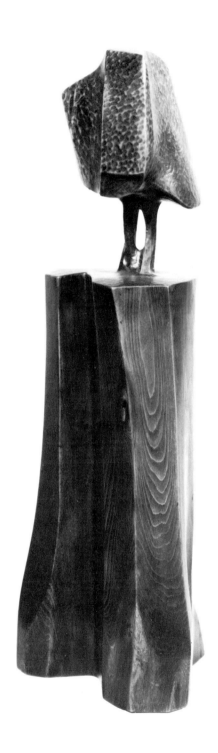

NEW GROWTH 1961 Juniper Ht. 17¼"
Collection: Private

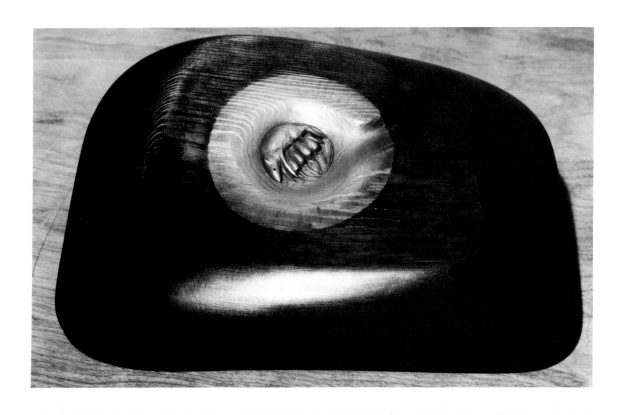

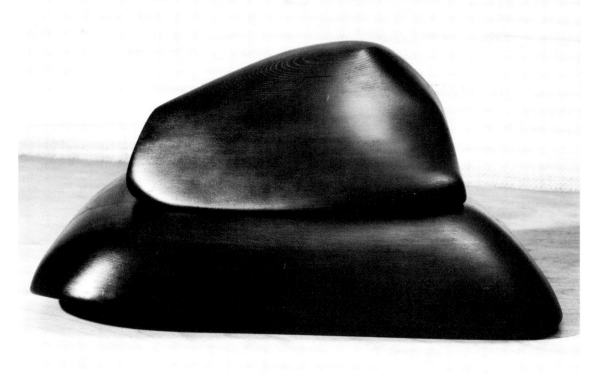

MEADOW ROCK 1961 Red cedar L. 15″
Collection: Private

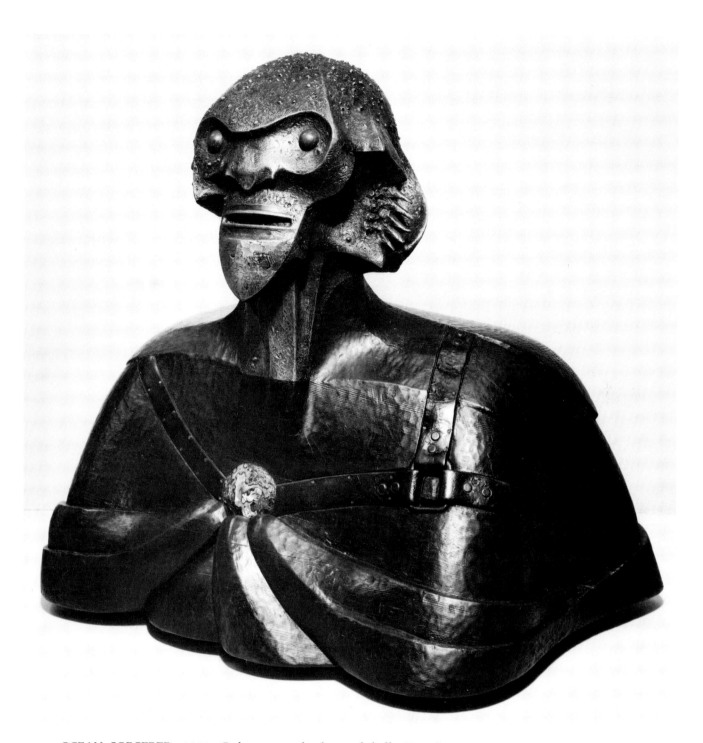

OCEAN SORCERER 1961 Cedar, pewter, leather, and shell Ht. 25″

The carapace of a kelp crab, not to mention tin cans and sea urchin
shells, went into the casting of the head of this wizard, who seems in
the act of rising through the waves to put on a performance involving
the mysteries of the deep but not without something of the humorous
magician's pleasure in confounding his audience.

This phantom has vanished, lost en route to the west coast after an
eastern showing, presumably in a train wreck whose smashed con-
tents were bulldozed into the midwest plains. Its vitality seems so
indestructible, however, that one can imagine it surfacing in some
later century to pose nice problems for archaeologists of the region.

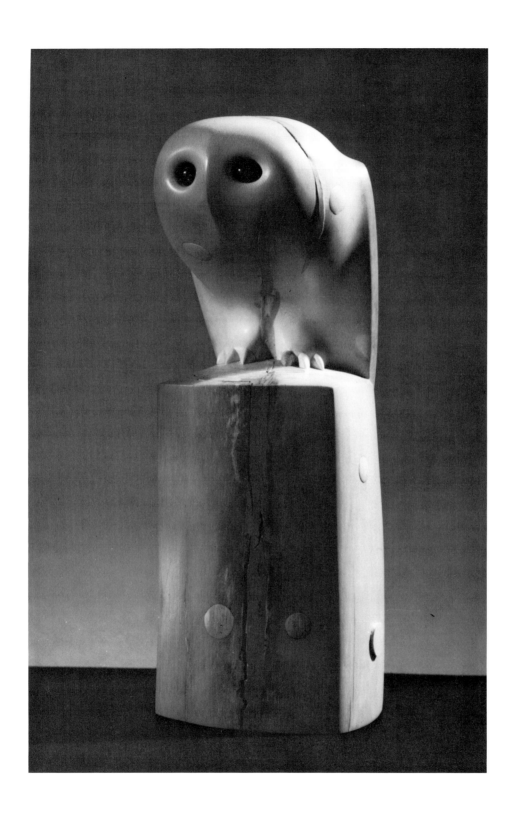

IVORY OWL 1961 Fossil ivory and garnet Ht. 9½″
Collection: Miani Johnson

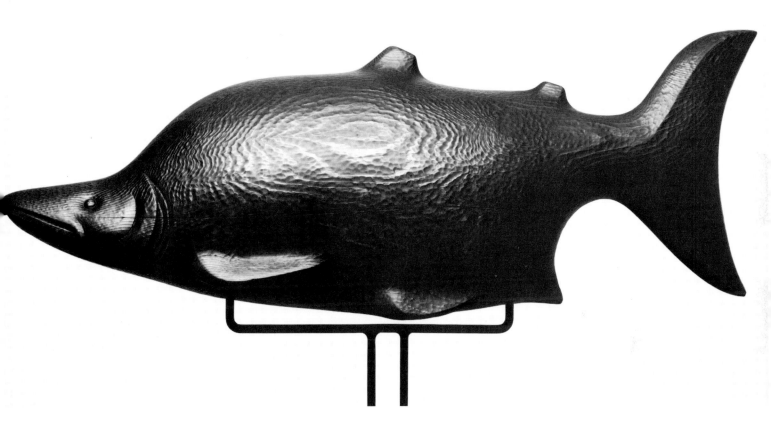

SPAWNING SALMON 1962 Cedar L. 45″
Collection: Private

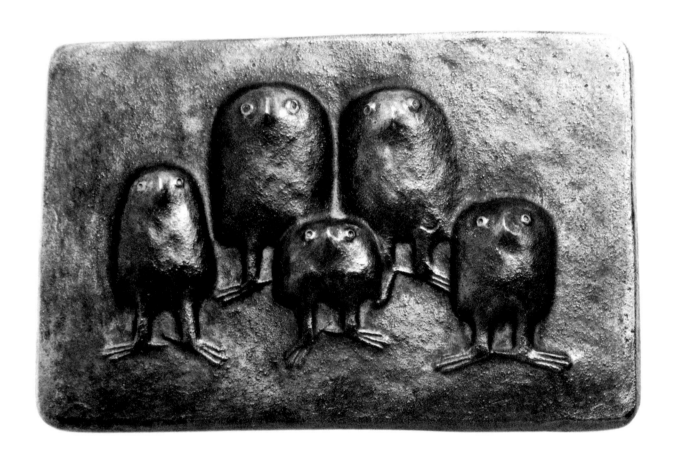

FAMILY PORTRAIT 1962 Bronze L. 8½″
Collection: Anne McCracken

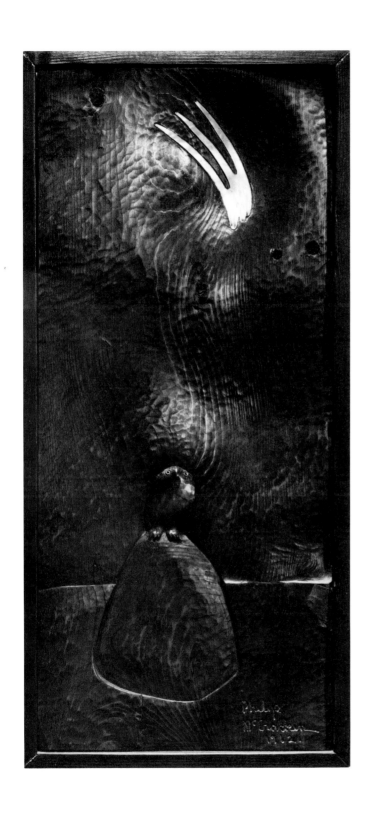

STARFALL 1962 Juniper and shell Ht. 14″
Collection: Private

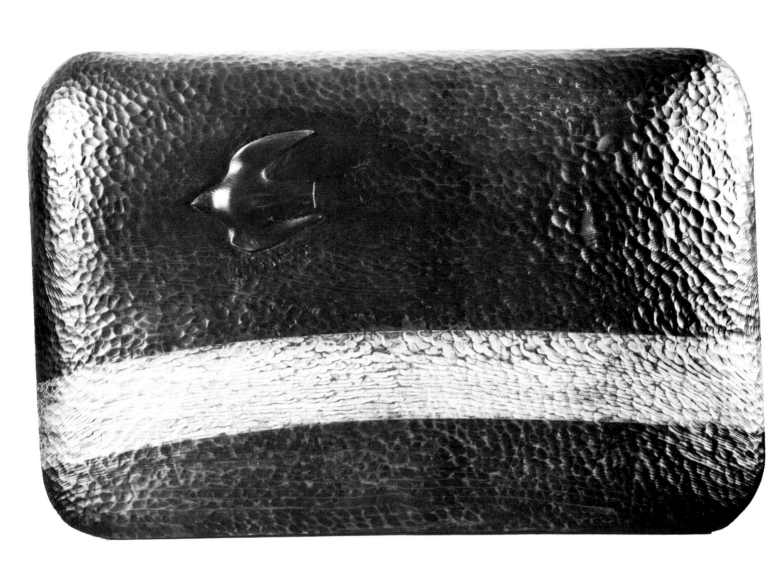

BIRD ON THE HIGHWAY 1962 Cedar L. 24½″
Collection: Private

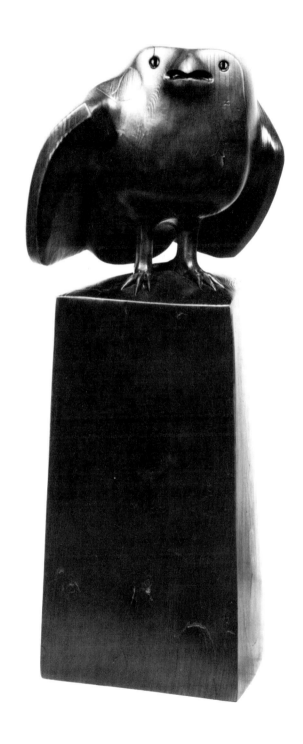

BIRD STANDING ALONE 1963 Juniper Ht. 14¾″
Collection: Private

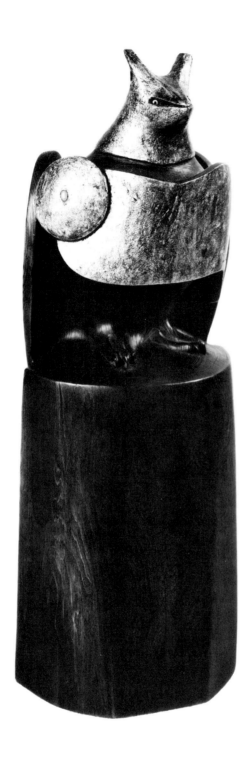

ARMORED BIRD 1963 Juniper, opal, and gold leaf Ht. 10½″
Collection: University of Oregon Museum of Art Collection,
Gift from the Haseltine Collection of Pacific Northwest Art, 1975

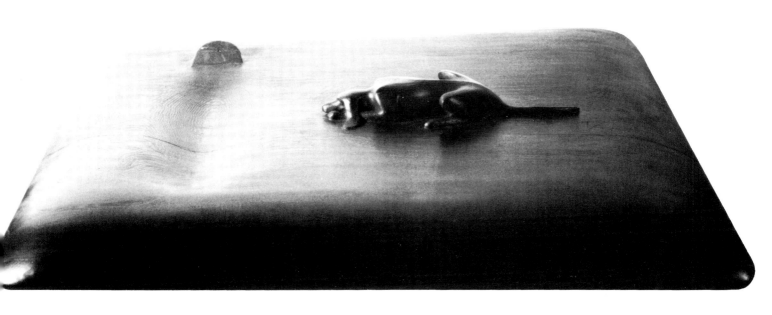

BLACK DOG 1963 Red cedar L. 24″
Collection: Wesley Rawhauser

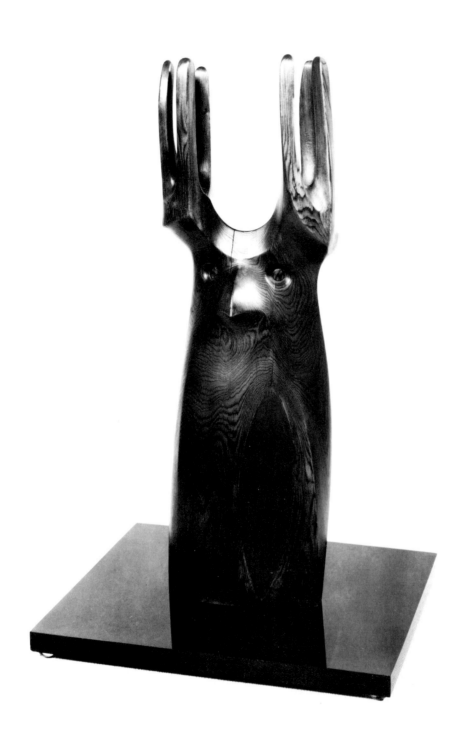

FOREST SPIRIT 1963 Juniper Ht. 12½″
Collection: Dr. Simeon Hutner and Dr. Frances C. Hutner

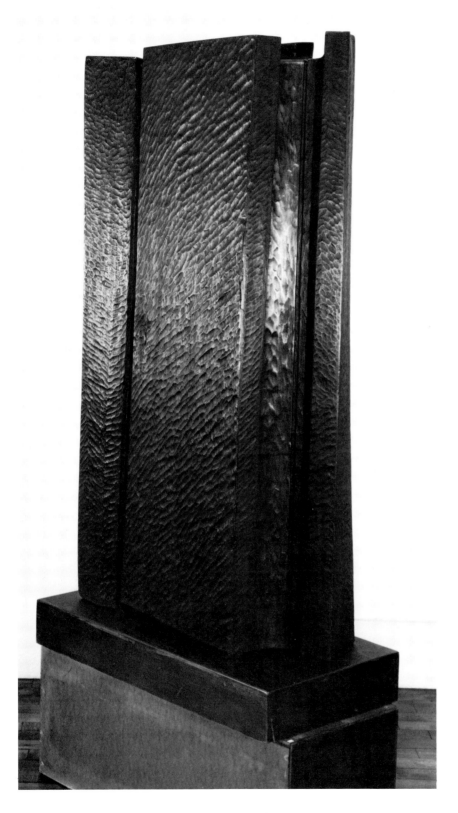

PASSAGE TO THE ISLAND 1963 Red cedar Ht. 46″
Collection: Department of Cultural and Recreational Services,
Anchorage, Alaska

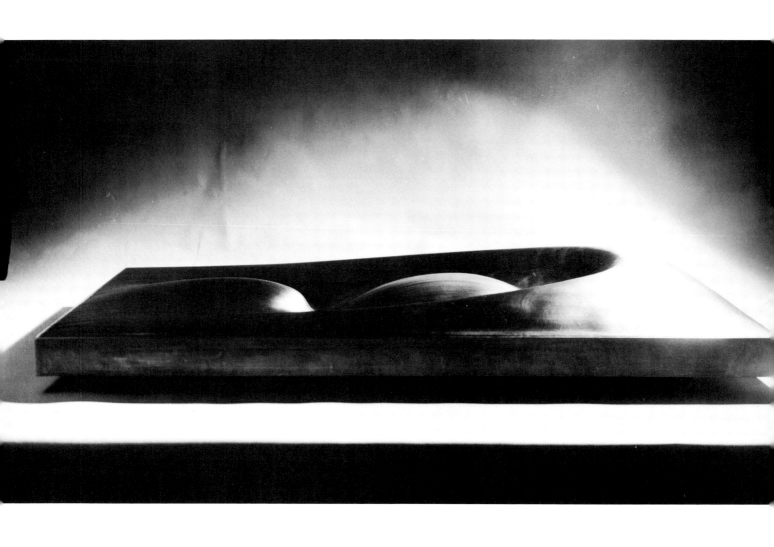

RIVER ROCK 1963 Red cedar L. 32″
Collection: Private

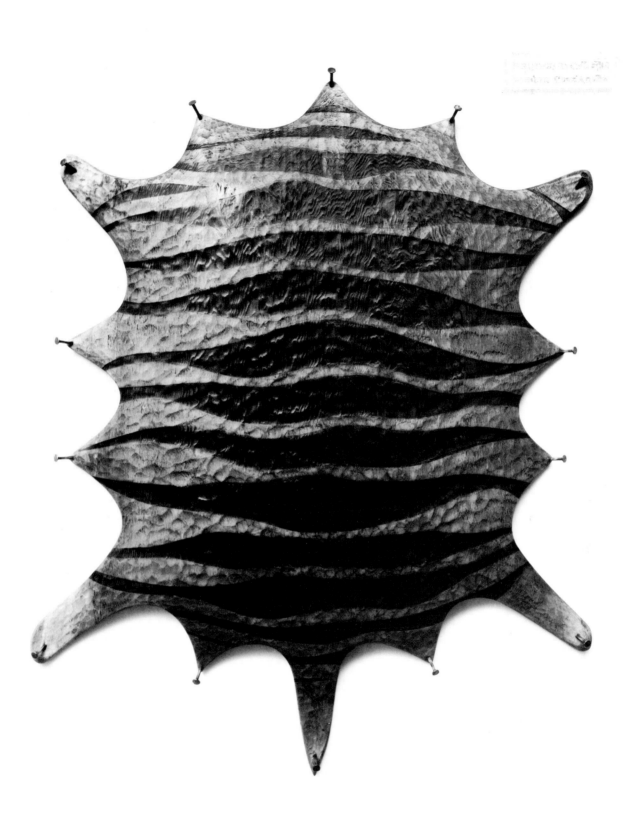

ANIMAL SKIN 1963 Red cedar L. 23″
Collection: Private

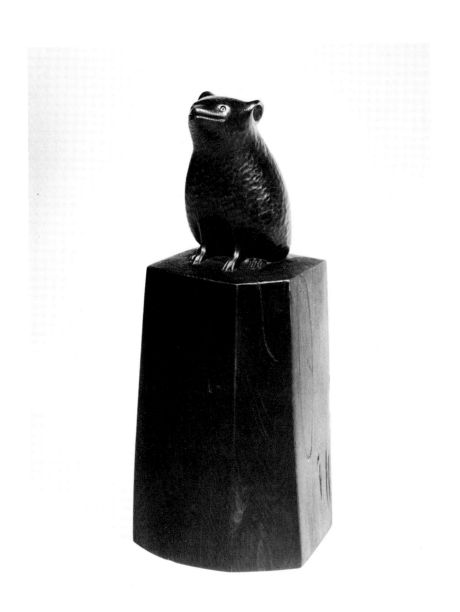

LITTLE MEDICINE BEAR 1963 Juniper Ht. 10″
Collection: Private

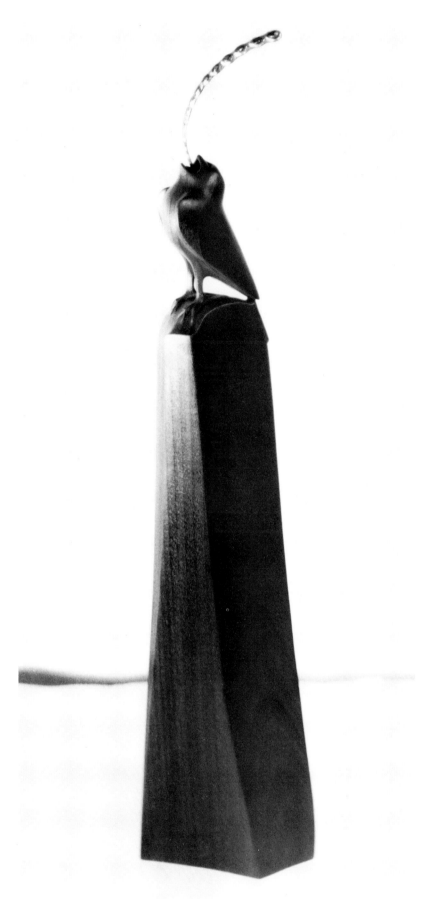

BIRD SONG 1964 Alder, shell Ht. 25"
Collection: Private

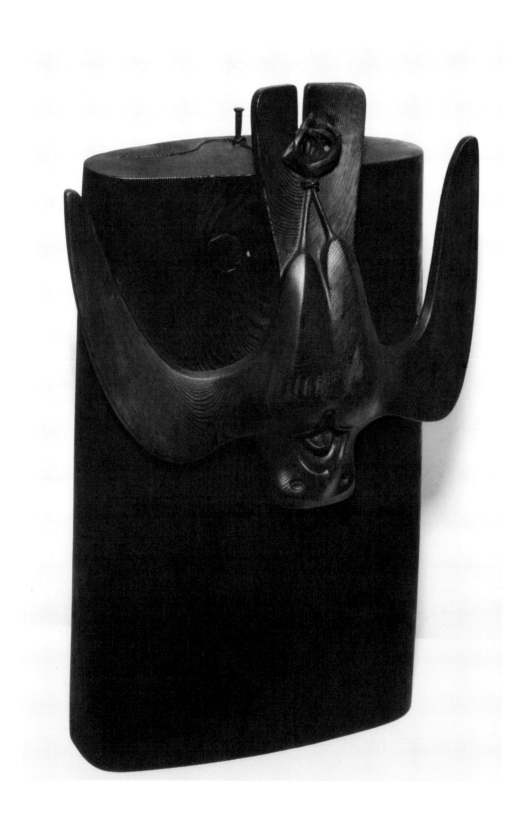

HANGING BIRD 1964 Red cedar Ht. 20½″
Collection: Seattle First National Bank

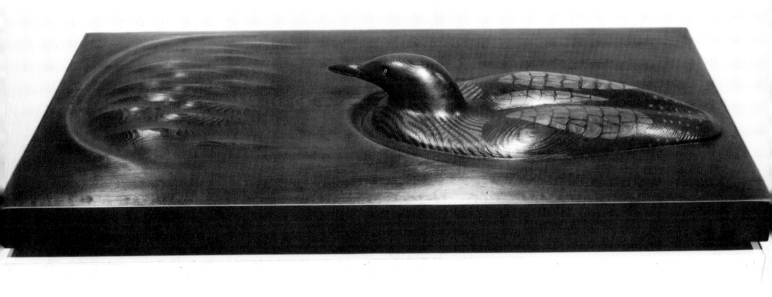

LOON 1964 Red cedar L. 37″
Collection: Mr. and Mrs. Lawrence A. Fleischman

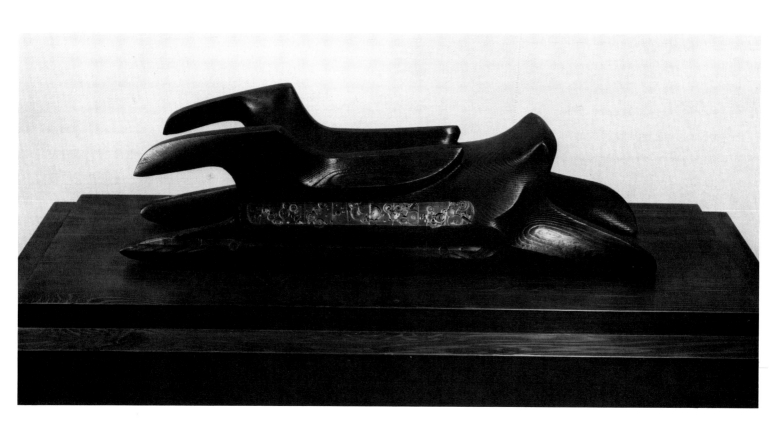

NEW MACHINE 1964 Red cedar and brass L. 39″
Collection: Private

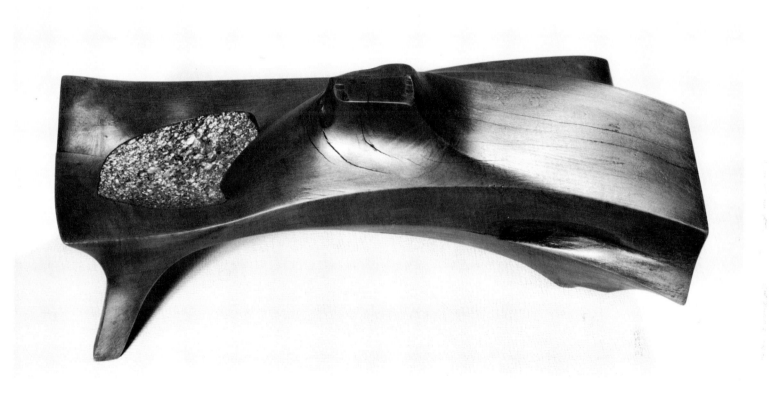

WALDEN 1964 Juniper and shell L. 12″
Collection: Private

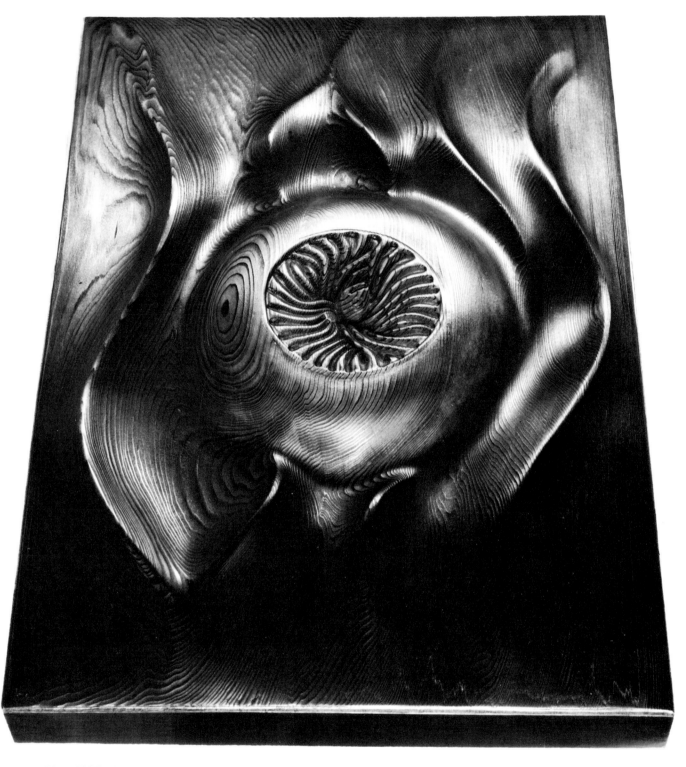

SEA ANEMONE 1965 Redwood L. 22¾″
Collection: Private

A search of the tide pools along the shore in front of the McCrackens' house
will turn up a number of anemone, their beautiful soft tentacles outstretched to
capture passing food. For the careless minnow the scene can become one of
horror as he is seized and ingested, slowly but inexorably.

 In this sculpture the fish is sucked in with an embrace that is almost tender.
The drama proceeds while the surrounding waves in their slow rhythms sug-
gest the vast impersonality of nature.

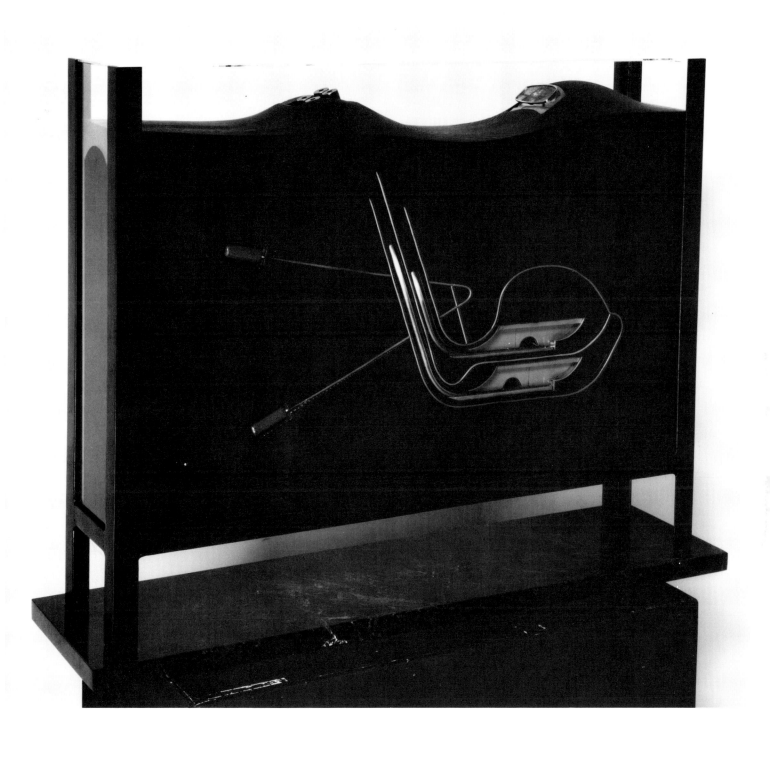

INSECT REVOLT 1966 Cedar, glass, and metal L. 20¼″
Collection: United Nations Association, New York

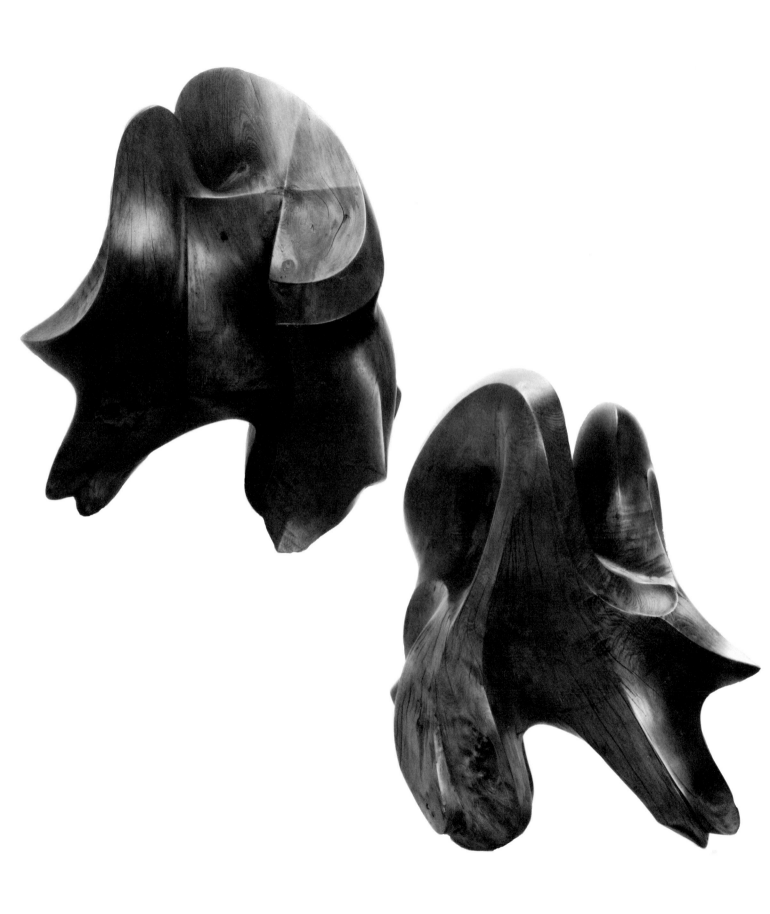

HUMAN HEART 1966 Juniper Ht. 16½″
Collection: Anne McCracken

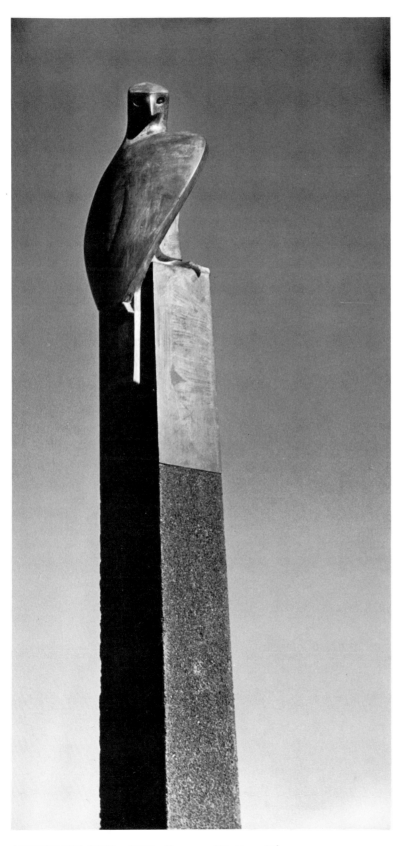

MOUNTAIN BIRD 1966 Bronze Ht. 4′ on 8′ base
Collection: City of Anacortes, Gus Hensler Memorial

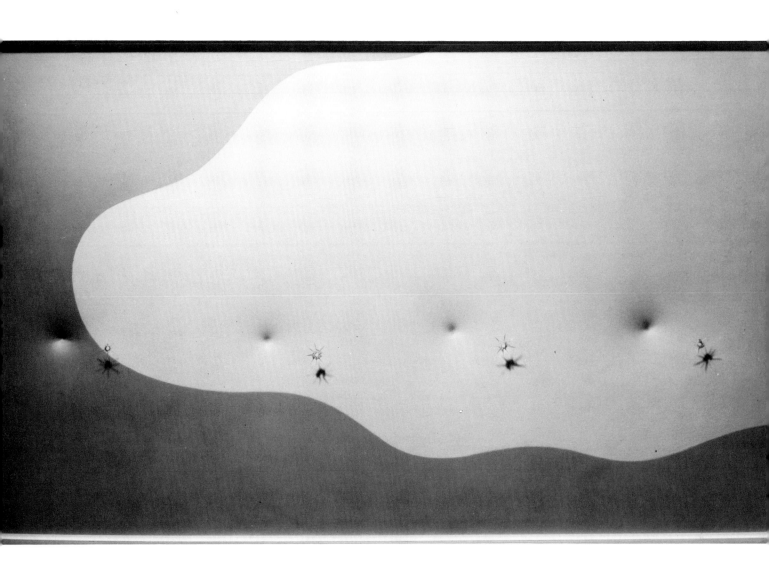

HEALED UP SKY 1967 Canvas, oil, and acrylic sheet Ht. 46½"
Collection: University of Oregon Museum of Art, gift from the
Haseltine Collection of Northwest Art, 1975

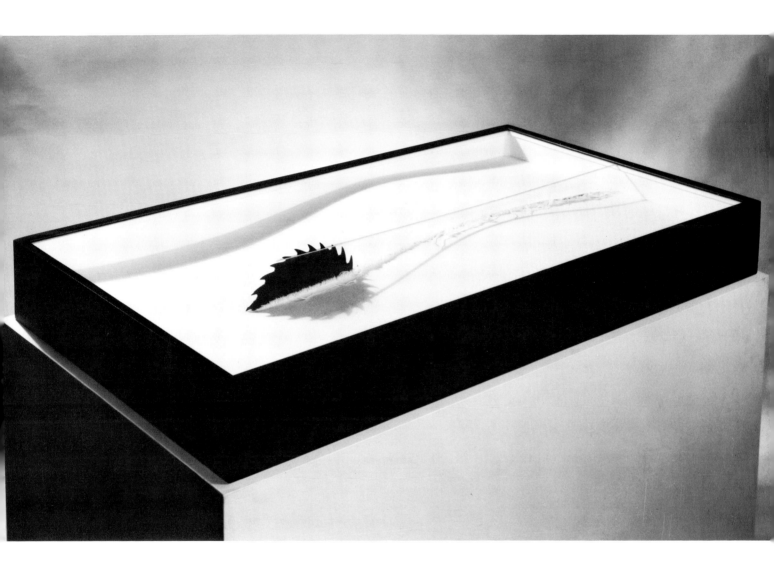

I SAW 1967 Metal, canvas, wood, and acrylic sheet L. 46½″
Collection: Museum of Contemporary Art, La Jolla, California

As the saw cuts smoothly into canvas and plastic there comes a feeling
that some inimical action is being undertaken with cold and frighten-
ing efficiency. The onlooker is permitted to observe the action at two
levels: he sees that the plastic (the outer shell of reality) is clean and
pure while underneath it is a different matter: the blade rips into the
canvas leaving in its wake torn and disheveled threads. Life, the artist
seems to be suggesting, is sometimes like that. Seldom in the actual
world, however, is evil caparisoned with such pristine beauty.

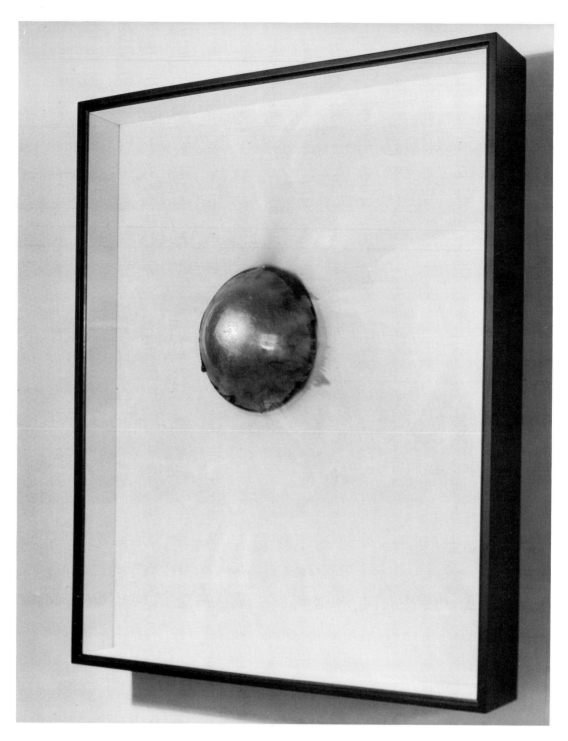

BURNING THROUGH 1967 Canvas, acrylic sheet, and gold
leaf Ht. 53½"
Collection: Anne Gould Hauberg

Of all the artist's sculptures this is perhaps least susceptible to verbal
analysis. The title is often applied to the sun as it dispels a morning
fog, and indeed at the back of McCracken's mind as he was making it
was the feeling that it might represent a moment of breakthrough to a
new realm of the spirit. Certainly on the physical side the gilded para-
bolic shape that presses through scorched canvas like some space cap-
sule nose cone, pushing out the covering plastic sheet like the node of
a shock wave, is a form charged with massive power to initiate change.
It has the ambiguity of all rich symbols.

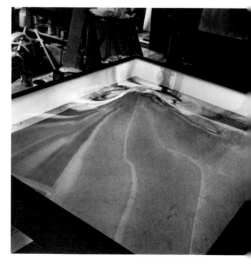

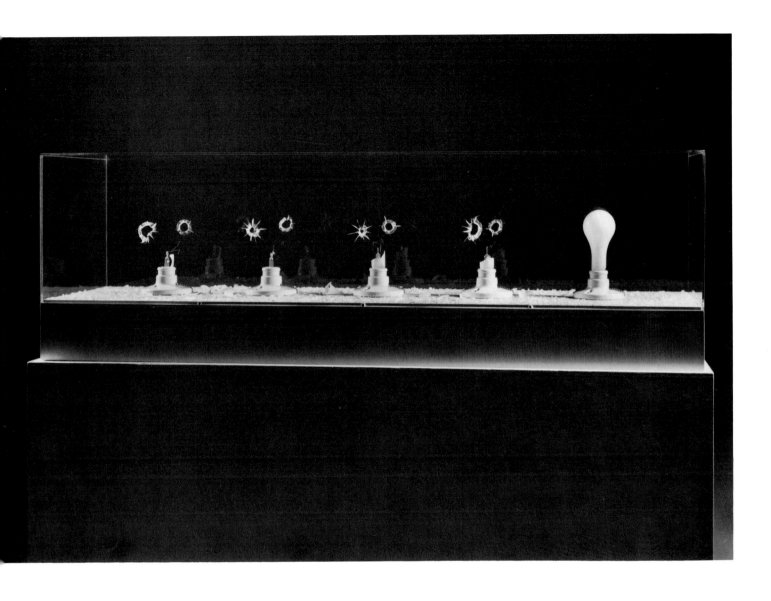

LIGHTS OUT 1967 Light fixtures, acrylic sheet, and wood L. 55¾"
Collection: Art Gallery of Greater Victoria, Victoria, Canada

The young look on with unclouded eyes. Not yet sharing their parents'
presuppositions as to what art is and isn't, they often see clearly where
adult vision is obscured by accretions from the past. While *Lights Out*
was being a source of puzzlement and even ridicule to much of the
mature public, third grade school children saw it at the Anacortes Art
Gallery and unerringly sensed its basic import:

"I think the bullet holes mean war with shooting and death. We are
not dead because there is one light bulb left."

"It makes me feel and think of the first world war, the second world
war, the Korean war, and the Vietnam war. The bulb that is still alright
is to show that in the end the world will be peaceful."

"I thought it meant one man did not go out to war and didn't get
shot . . . the others was foolish."

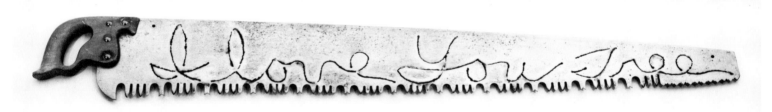

I LOVE YOU TREE 1967 Steel and wood L. 62″
Collection: Private

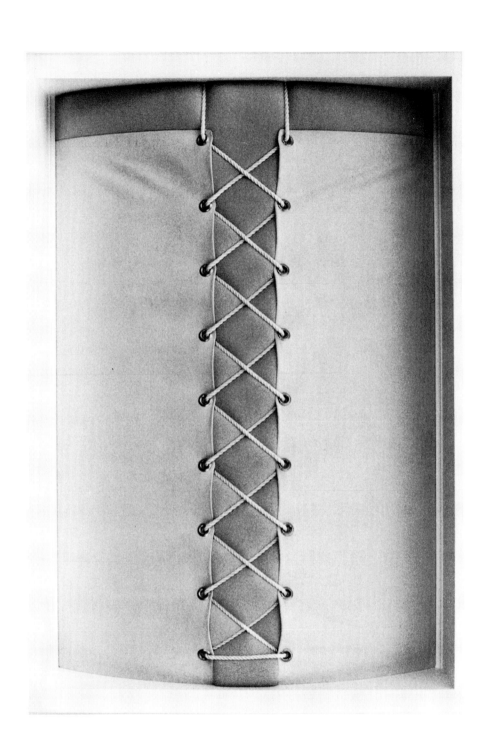

AMERICAN LACE 1968 Foam plastic and canvas Ht. 50″
Collection: Philip McCracken

173 PARKSIDE 1968 Photograph, wood, and plastic Ht. 44¾″
Collection: Philip McCracken

Two kinds of reality subsist here side by side. Opposing the smooth
double camera image of the standing tree is the highly tactile slab from
an actual tree. The camera image of reality is thus placed in a provoca-
tive context vis-à-vis the real thing.

While all this is intriguing as a metaphysical dialogue of opposites,
the work so far has scarcely entered the realm of visual poetry. It is
only when the red reflector disc (a warning signal) is fixed to the bark
that an esthetic transformation occurs. Suddenly the composition
"gels" and the total image moves into slightly disquieting regions of
the imagination.

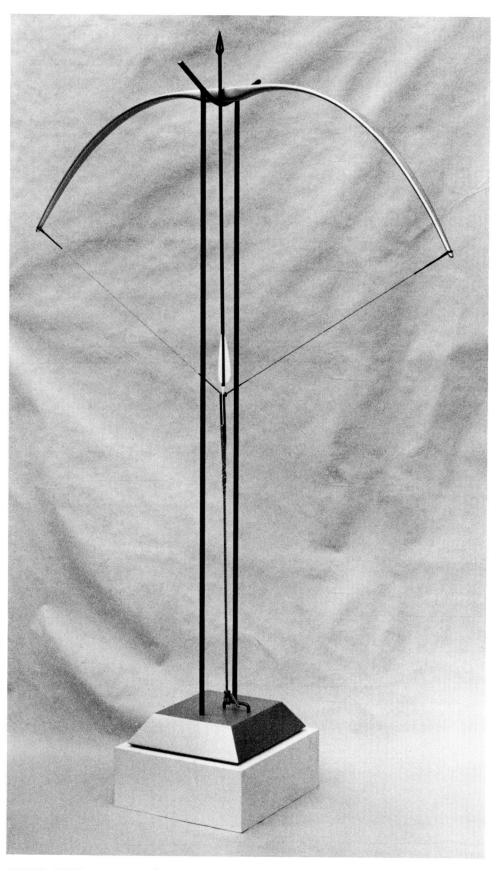

SILVER BOW 1969 Steel, plastic, and wood Ht. 6′ 5½″
Collection: Anne Gould Hauberg

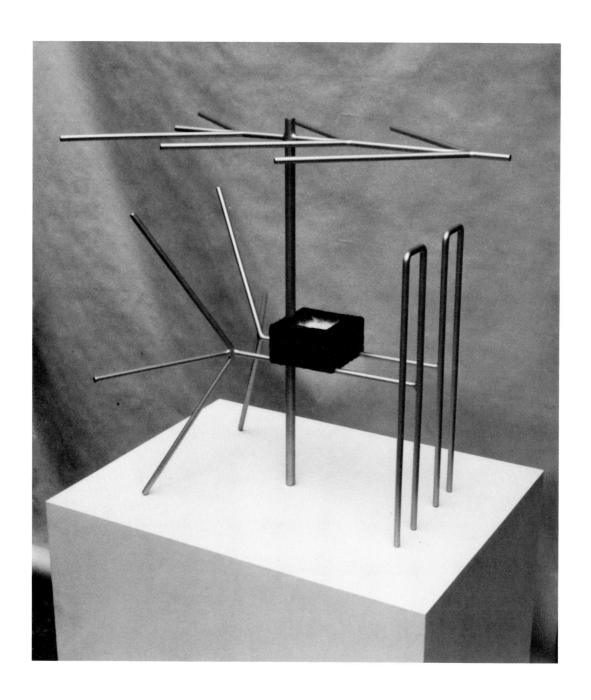

AERIAL NEST 1969 Glass, wood, steel, and bird's down Ht. 31"
Collection: Philip McCracken

"The inspiration for *Aerial Nest*," wrote the artist shortly after this piece was made, "can be found in the [New York] Museum Of Natural History: a bird's nest found downtown and built entirely of assorted metal debris." He went on, "I admit to its influence, and the debt I owe it for first awakening, in 1955, the realisation of the promise of new possibilities, sometimes frightening possibilities, that exist in the opposing yet inexorably joined forces at play between man and his environment."

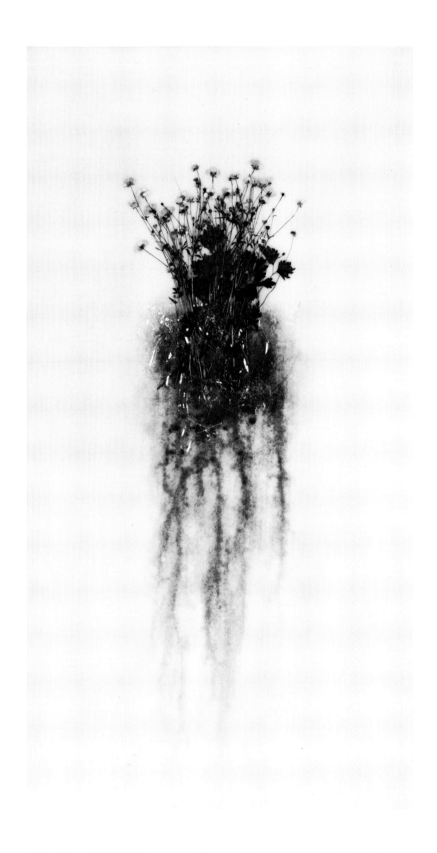

PRESSED FLOWERS 1969 Flowers, glass, tempera, foam plastic,
and acrylic sheet Ht. 45½"
Collection: Tacoma Art Museum, Aloha Club Collection

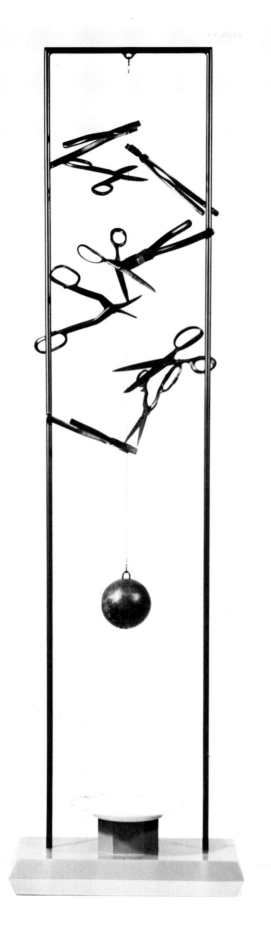

LIMOGES 1969 Steel, lead, and porcelain Ht. 67½″
Collection: Anne Gould Hauberg

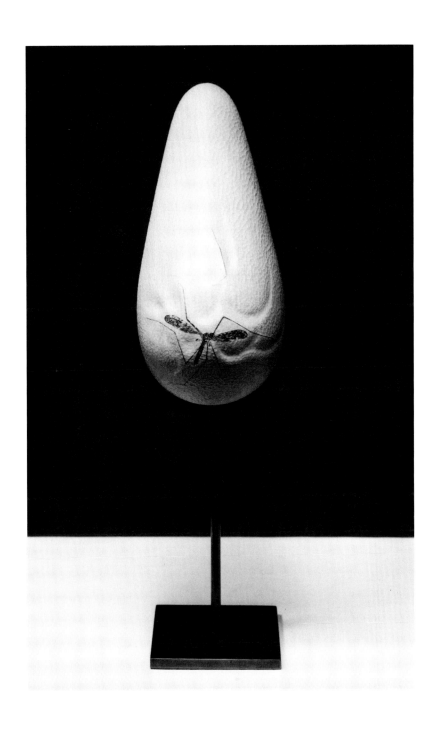

RAINDROP 1971 Cedar and photo emulsion Ht. 20¾″
Collection: Private

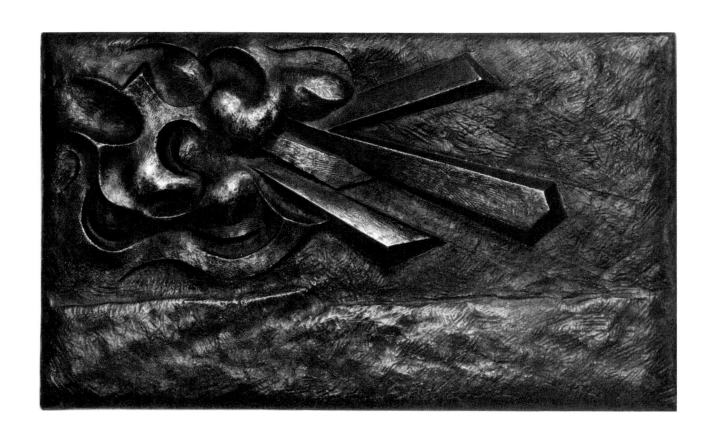

THUNDER ON THE DESERT 1972 Bronze L. 11¼″
Collection: Private

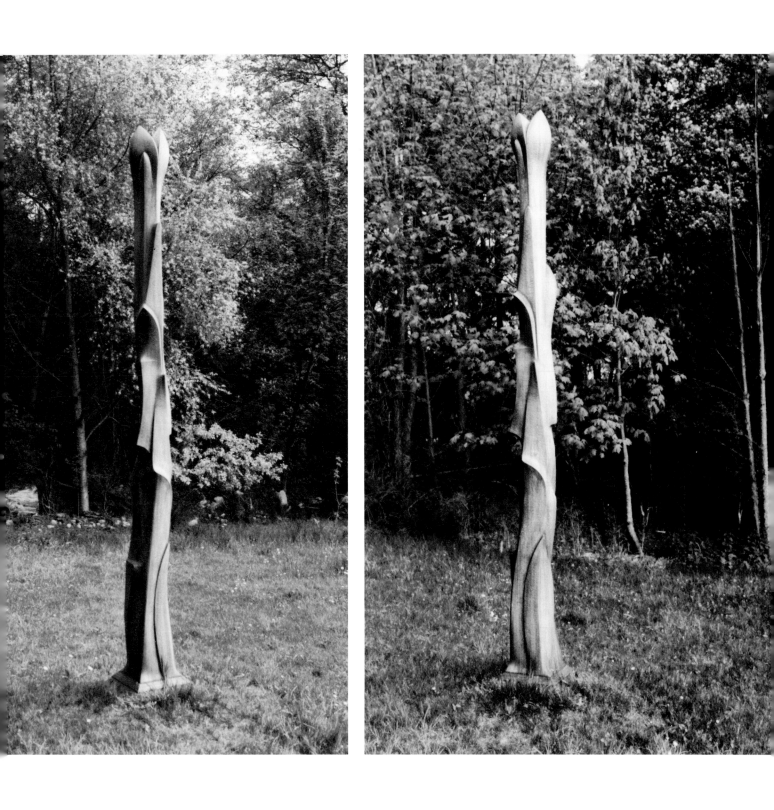

SPRING 1972 Red cedar Ht. 16′
Collection: Private

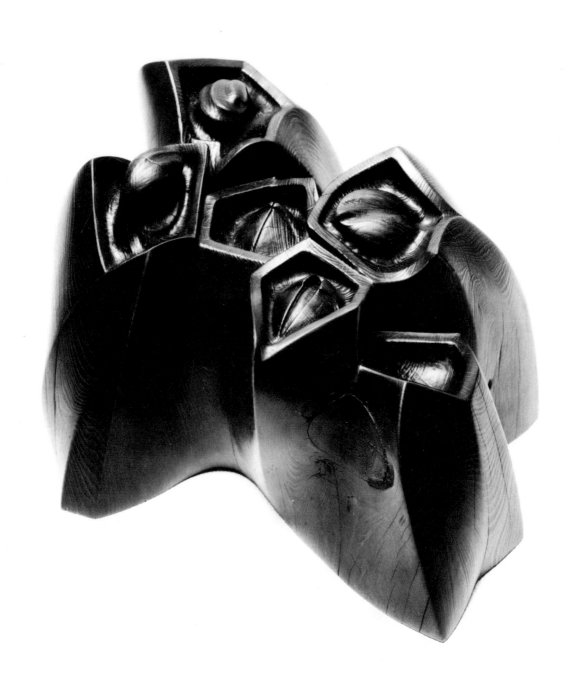

BARNACLES 1973 Juniper Ht. 5⅜"
Collection: Dr. and Mrs. Harold Clure

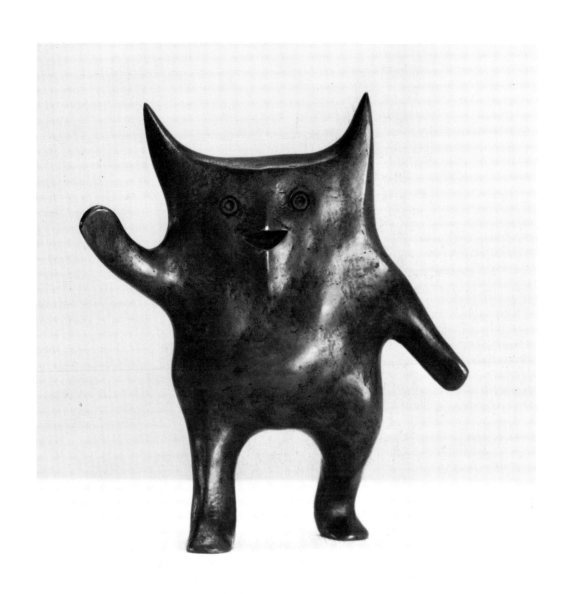

LITTLE MAIDEN BUFFALO WALKING MASK 1973
Bronze Ht. 5″
Collection: Private

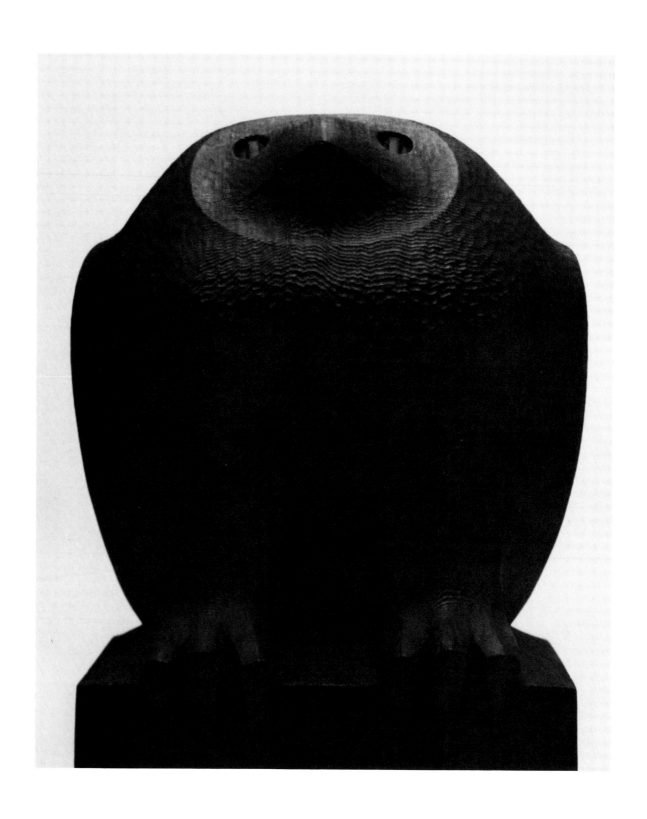

GUARDIAN 1974 Cedar Ht. 5′1″ including base
Collection: Seattle First National Bank, Mt. Vernon

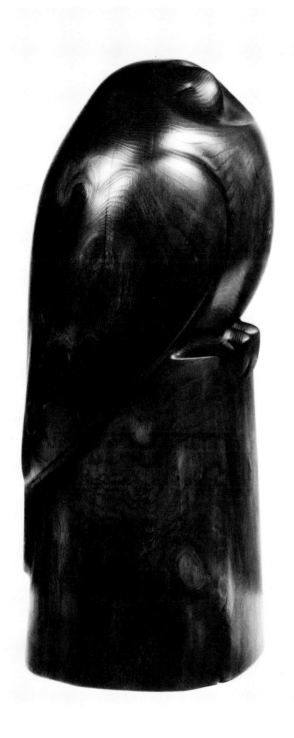
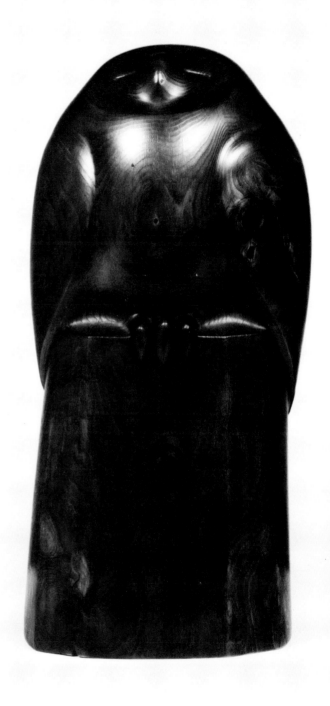

NIGHT BIRD 1974 Yew Ht. 15¾″
Collection: Tacoma Art Museum, gift of the Aloha Club

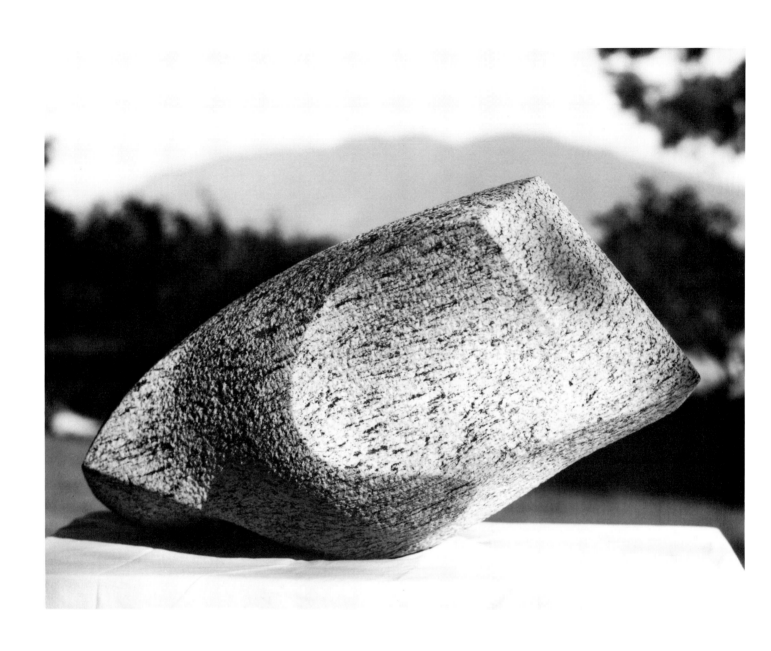

STONE POEM 1974 Granite L. 25″
Collection: Laurie Lancaster

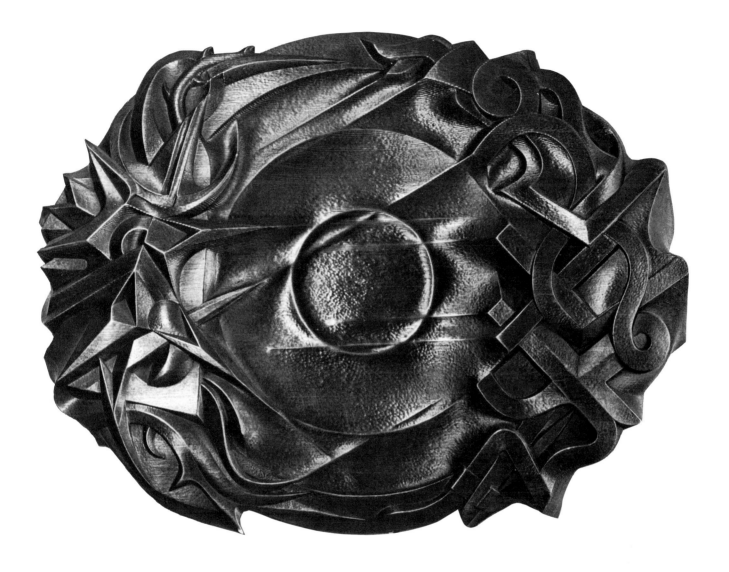

MEDICINE WHEEL 1974 Cedar Ht. 26½"
Collection: Private

Medicine Wheel began with drawings of instruments that record phe-
nomena beyond ordinary human perception such as barometers and
seismographs. The readings such as low-high, fair-stormy, took on the
further dimensions of yin-yang, good-evil, love-hate, with no definite
breaking off point, but rather with a space of subtle exchange existing
between them. This space is expressed in the sculpture as a great
cosmic sea enclosed in the circle, and washing upon the shores of the
forms reaching into it. (Analysis by the artist).

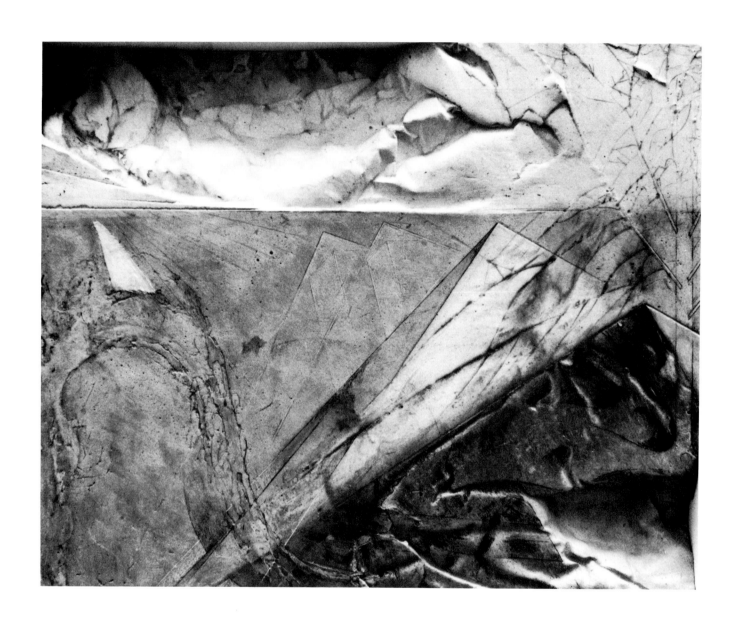

PYRAMIDS AND SEASCAPE 1974 Fresco and pencil Ht. 11½″
Collection: Private

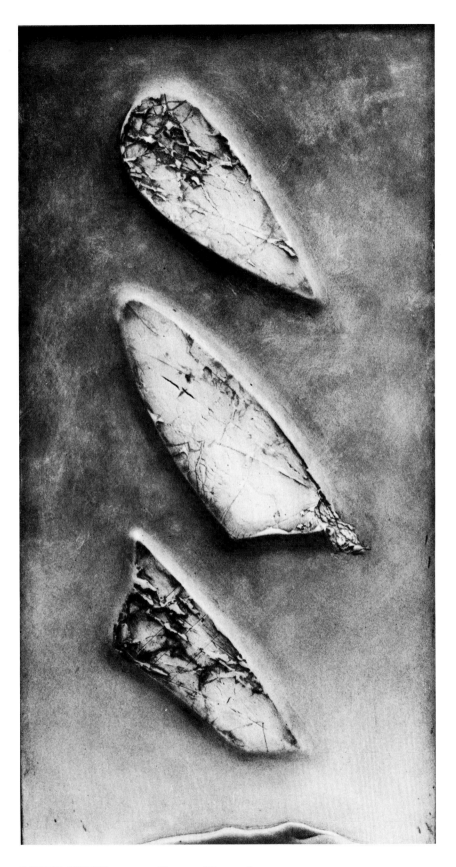

INSECT WINGS 1975 Fresco Ht. 22½″
Collection: Private

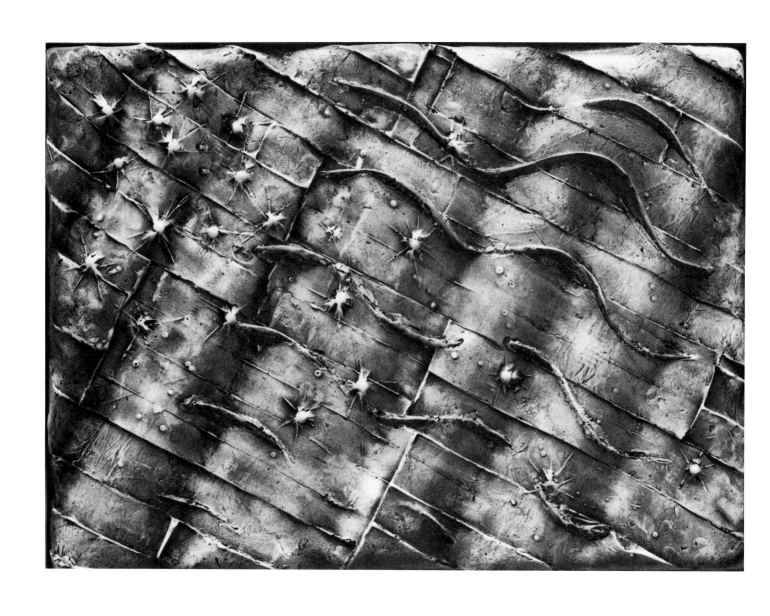

FLAG 1975 Fresco Ht. 14⅞″
Collection: Whatcom Museum Collection, Bellingham

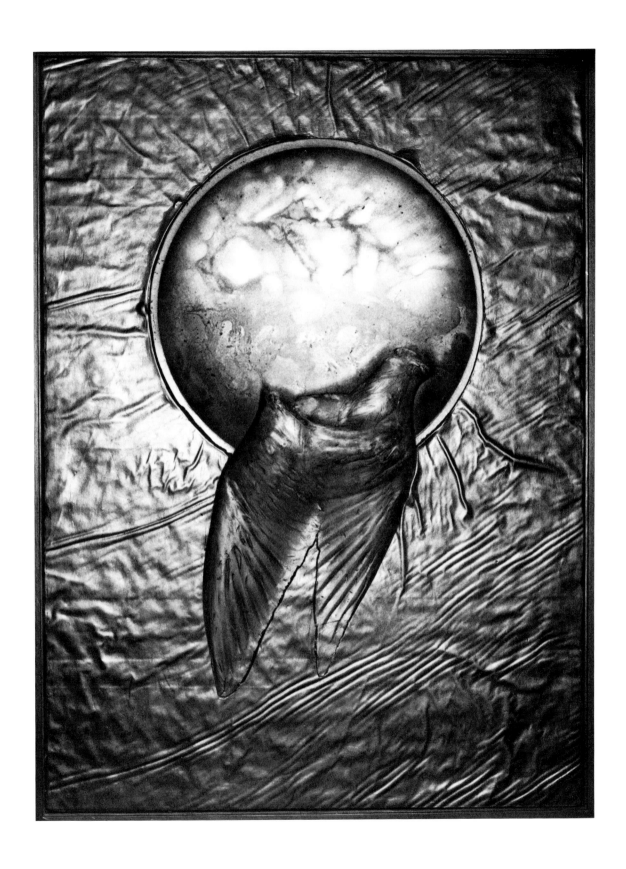

GREEN WING SHIELD 1975 Fresco Ht. 39¼″
Collection: Helen and Marshall Hatch

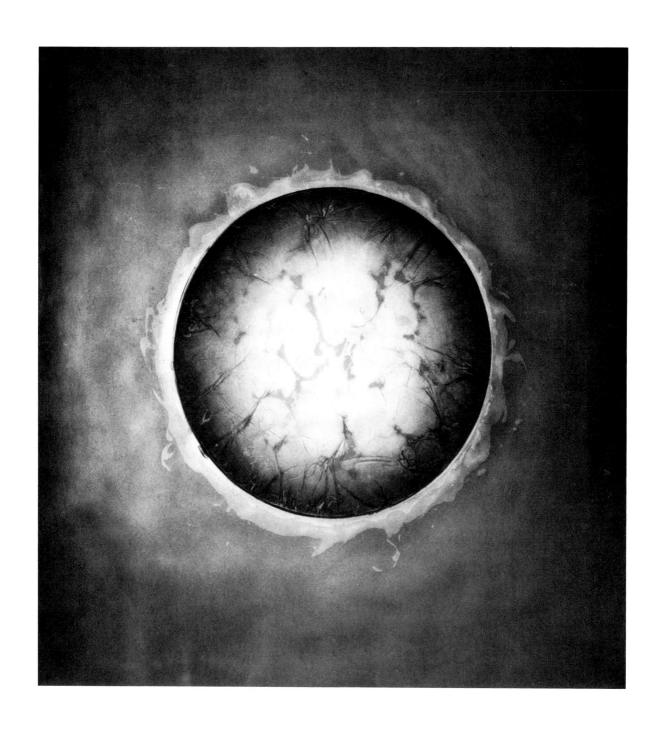

RED DWARF 1975 Fresco Ht. 33½"
Collection: Dr. and Mrs. Jack L. Reid

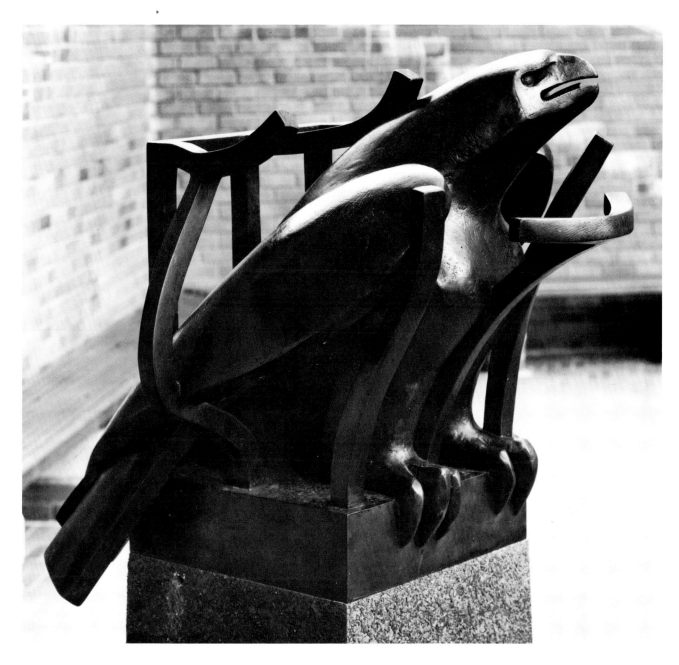

FREEDOM 1976 Bronze Ht. 23½"
Collection: Federal Building, Seattle, General Services Administration, Region 10

"This sculpture is among the first in a reappearance in my work of bird forms which have been absent from it since 1966. Although I have done many bird form sculptures, specific birds seldom appear in my work, and that is true of this piece. It is the *birdness* as a vehicle for the expression of a vast range of life currents that interests me. Further, this sculpture is not intended to represent a specific religious or political condition, but is meant to be translated into the terms each viewer personally sees as representing his own freedom." (Philip McCracken, 1976)

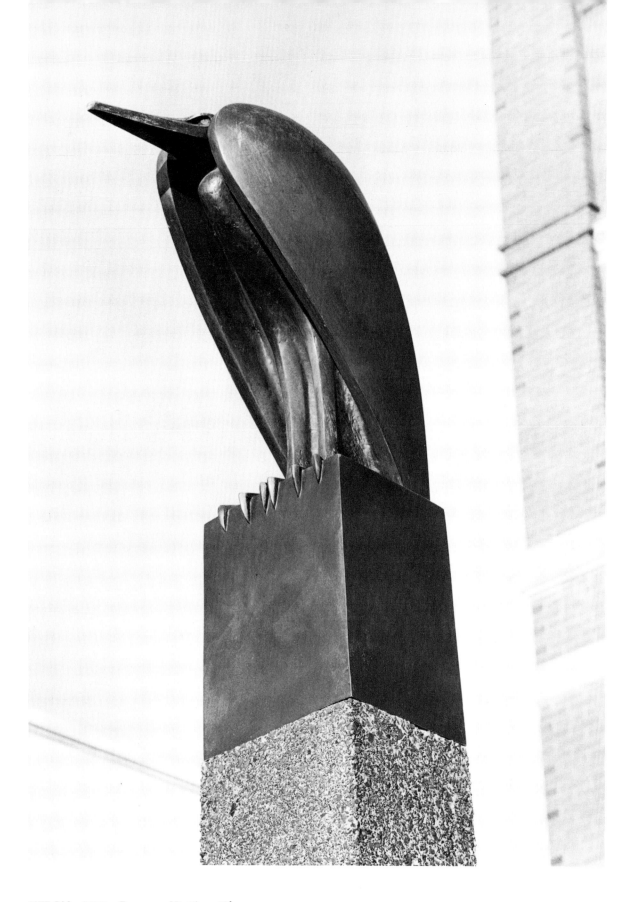

HERON 1977 Bronze Ht. 3′ on 9′ base
Collection: Whatcom Museum, Bellingham
Purchased with the assistance of the National Endowment for the Arts
and the Whatcom Museum Society

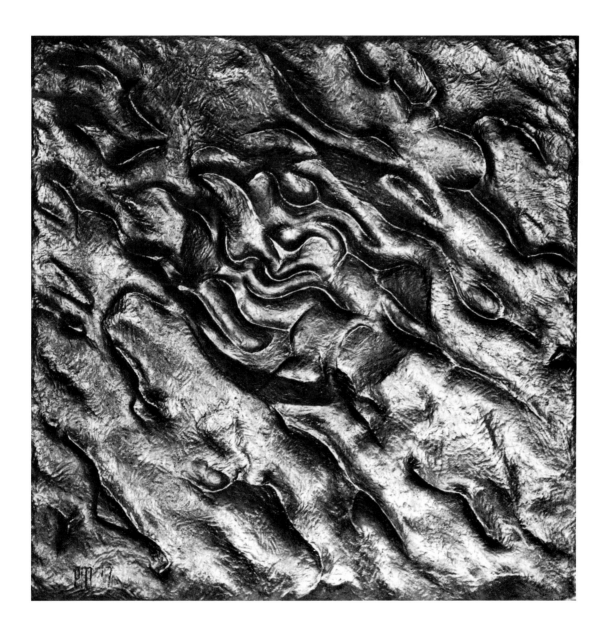

EARTH, SUN, AND MOON 1977 Three bronzes each 2′ × 2′
Collection: Anacortes School District No. 103

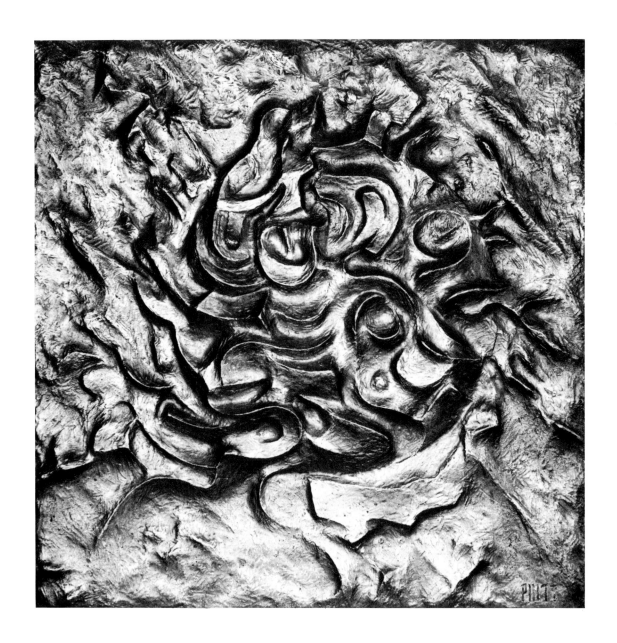

SUN 1977

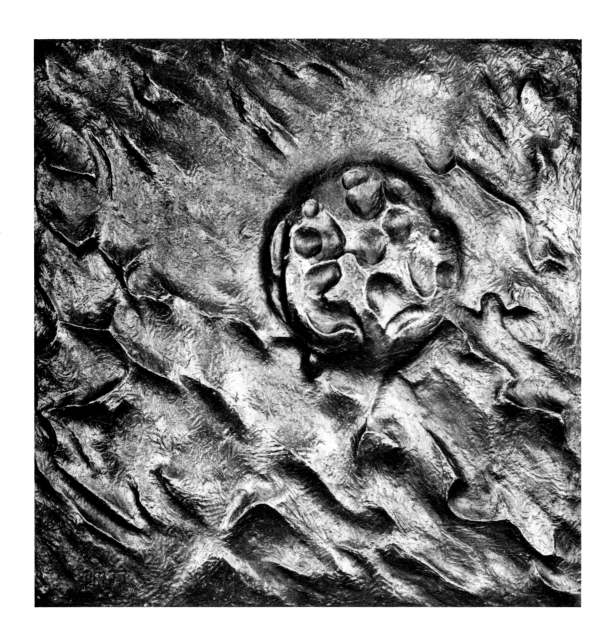

MOON 1977

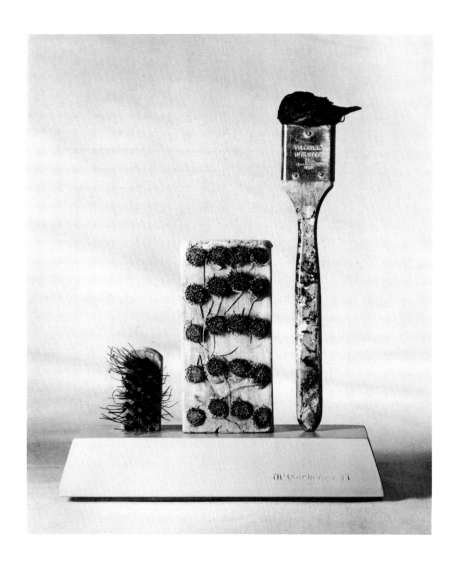

FAMILY GROUP 1977 Brushes Ht. 11"
Collection: Helen and Marshall Hatch

"These playful spontaneous sculptures have come about after a heavy
season of work under the discipline of commissioned sculpture. They
were approached in a spirit of lighthearted investigation, but with a
dark minor chord running through them also. Some of these ideas
flashed upon my mind during the course of using the tools, such as the
brushes and trowels. At other times it was a slow awakening of an
idea—such was the case with the pieces using the dried and plastic
fruit. These objects had accumulated in the studio, I didn't know what
for, until their time came. This is one of the rewards of making art—the
apparently never ending well of surprises.

"I laughed often while doing these small tableaux, but occasionally
the laughter was interrupted with a wince of deeper recognition,
sometimes sadness. At other times it was reversed. An idea I thought
was so serious came out sad-funny, or combinations of these things—
laughing with a side ache." (Notes by the artist dated 1977)

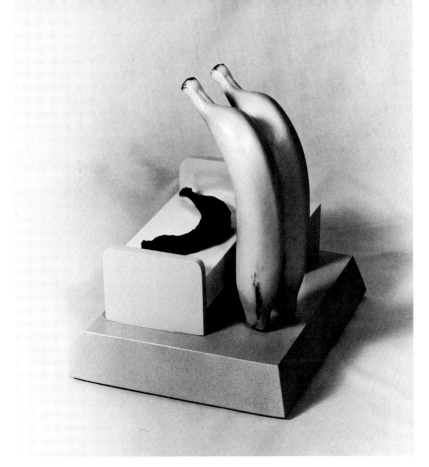

VISIT 1977 Bananas (one real, two plastic) Ht. 9½"
Collection: Dr. and Mrs. Jack Inman

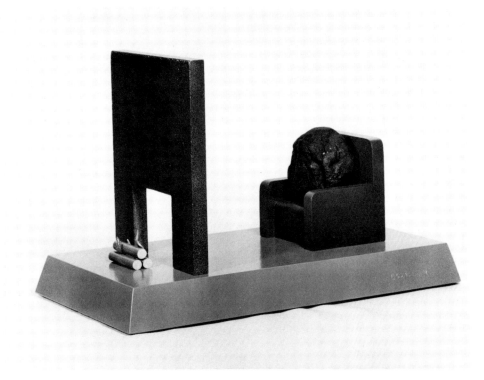

BY THE FIRE 1977 Grapefruit, wood, and lead Ht. 9½"
Collection: Philip McCracken

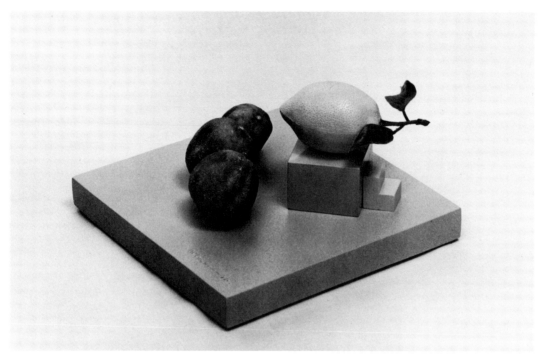

LECTURE 1977 Lemons (one plastic, three real) Ht. 4½″
Collection: Philip McCracken

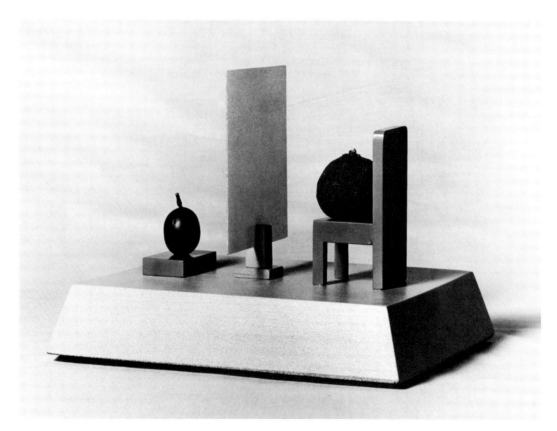

CONFESSION 1977 Plastic grape and real orange Ht. 6¼″
Collection: Miss Margaret Hamilton

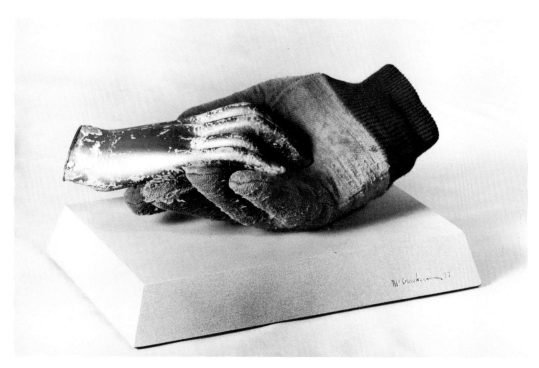

HANDS 1977 Plastic, cloth, and plaster Ht. 5¼″
Collection: Jon Dahle

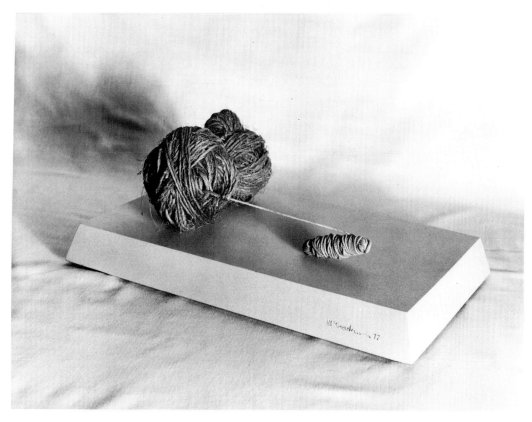

A WALK 1977 String Ht. 5½″
Collection: Philip McCracken

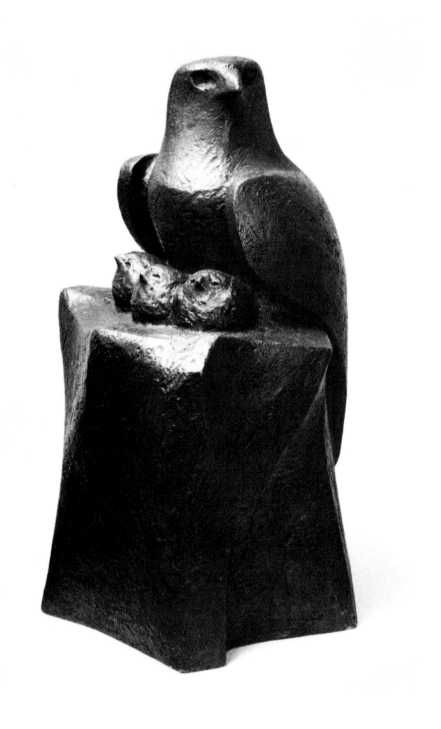

MOTHER AND YOUNG 1977 Bronze Ht. 14″
Collection: Private

BIRD SONGS 1978 Oil on wood panel 24″ × 17″
Collection: Philip McCracken

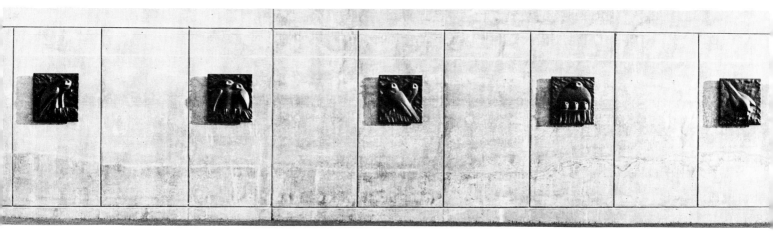

KINGDOME BRONZES 1978 Five bronzes each 25″ × 26″
Collection: Kingdome, Seattle
Commissioned by King County Arts Commission

Although these sculptures must speak for themselves, I can tell you
something about their background.

"The history of these bronze bird forms began in 1954 in England. I
was then working as an assistant in Henry Moore's studio there, and
he had suggested to me that when I could I should go on into London
and see certain works that were there in the British Museum—the
Elgin Marbles among them. He has great respect for these old cultural
masterworks. I did then visit the British Museum, and among the
things I found there were some limestone relief sculptures of birds and
animals done by Greek sculptors around 470 B.C. These together with
the Egyptian and Assyrian friezes made a profound impression on me
and I returned again and again to look at them.

In the summer of 1977 we were in England again essentially for two
reasons—one to visit the Moores, and the other to research in a broad
sense two upcoming sculpture commissions. One of these had to do
with figurative works for a Benedictine monastery, the other these
relief sculptures you see here. Well, I was very restless about settling
on what I was going to do here. I had done some preliminary drawings
on Guemes before I left that didn't strike any sparks, but on visiting the
British Museum and those old friends there I did feel something stir-
ring. One morning in Sussex I awoke early—perhaps five o'clock—
very restless, but feeling good—beautiful morning—flowers bloom-
ing—larks rising from the fields. I sat down and did the drawings for
these pieces in perhaps five or ten minutes. None of them changed
except a slight change in gesture of the last one on the right. Well, I
was elated of course. I knew I had them right then, but on further
reflection I also realized that they had been germinating since 1954
when that young sculptor was awed by the presence of those master-
works looking out of their stone and bronze lives into, through, and
beyond my own. I hope that some of that transcending power in those
ancient images has found its way through my own voice to you
through these sculptures." (Philip McCracken speaking at the inaugu-
ration of these bronzes at the King Dome, Seattle, April 25, 1978.)

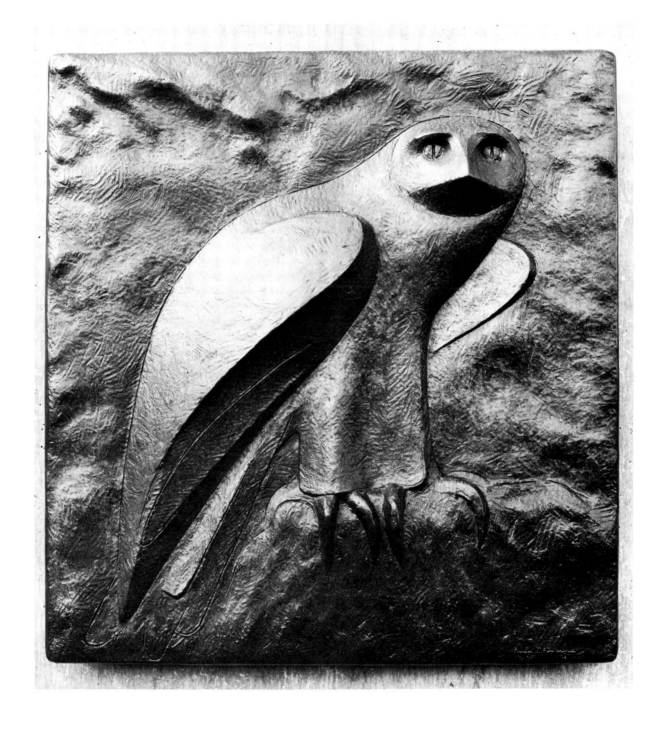

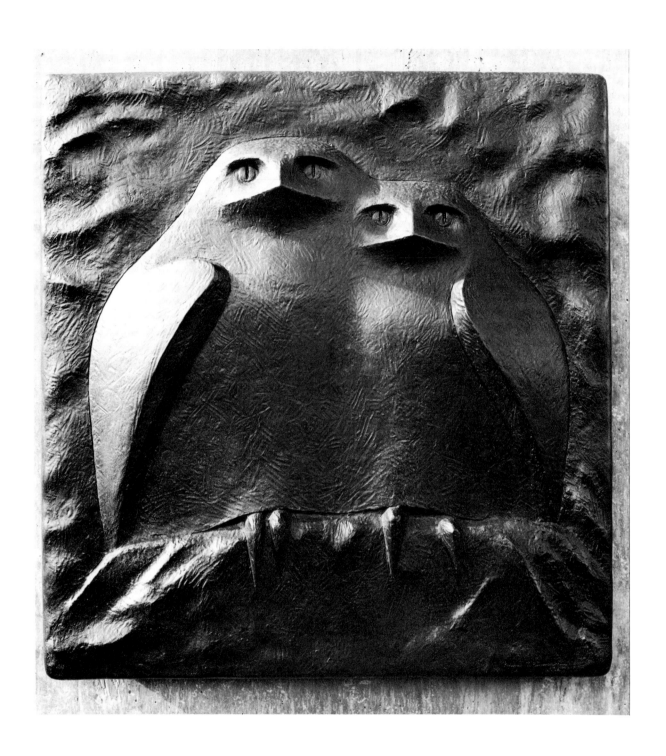

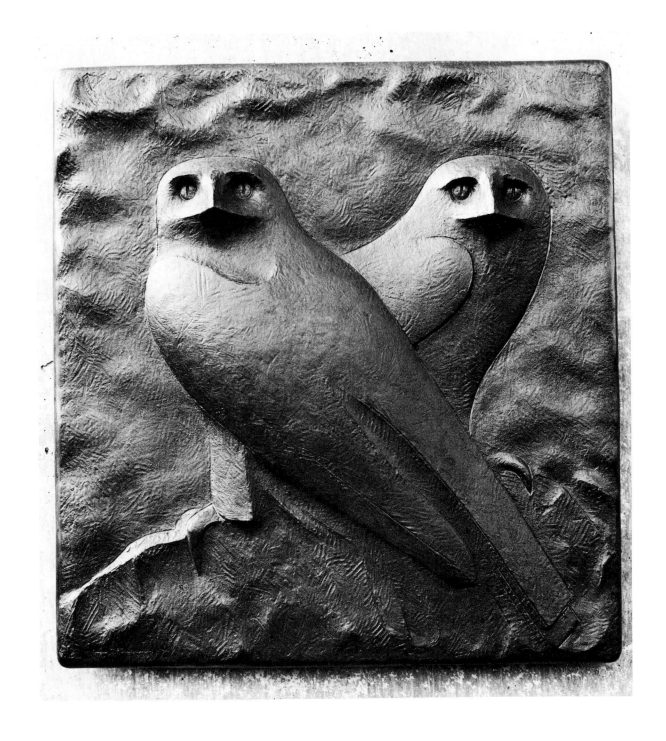

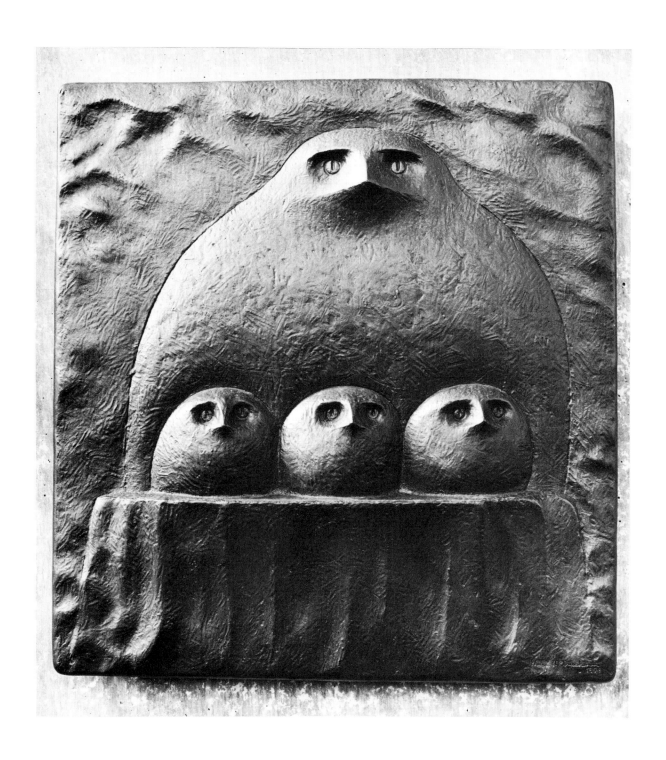

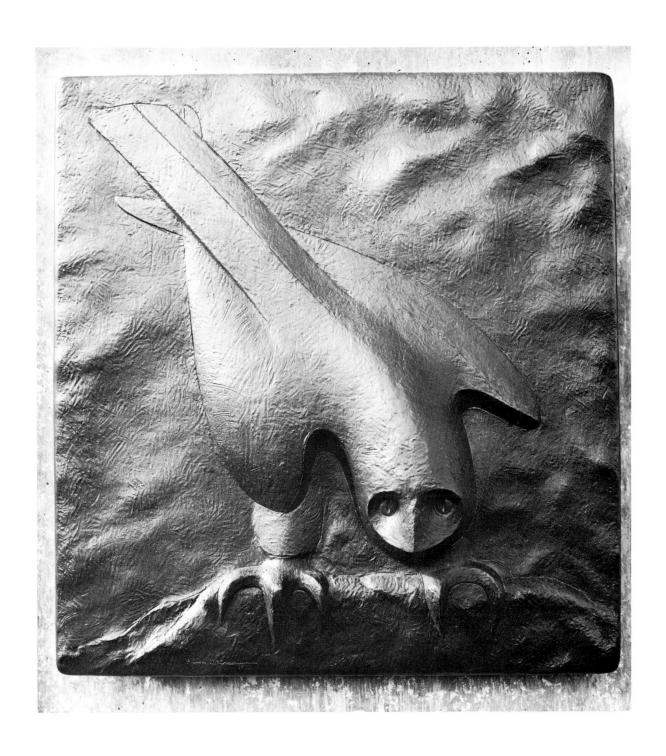

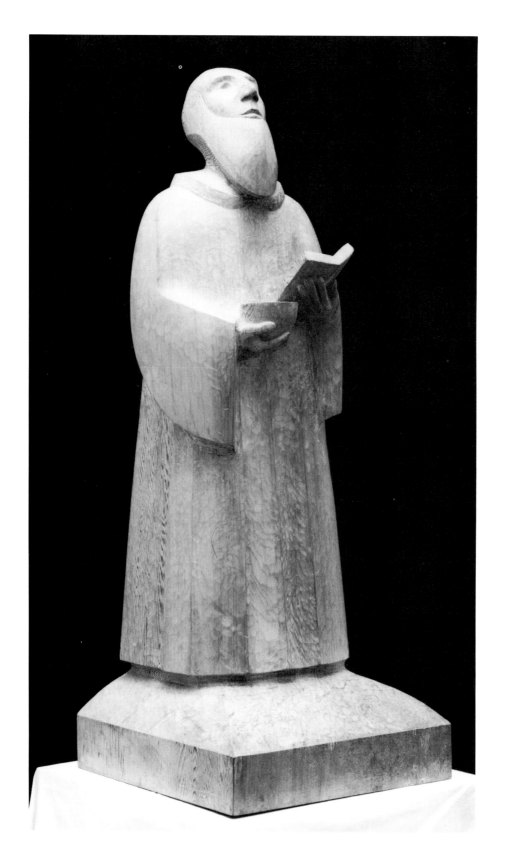

ST. BENEDICT 1979 Cedar Ht. 35″
Collection: Private

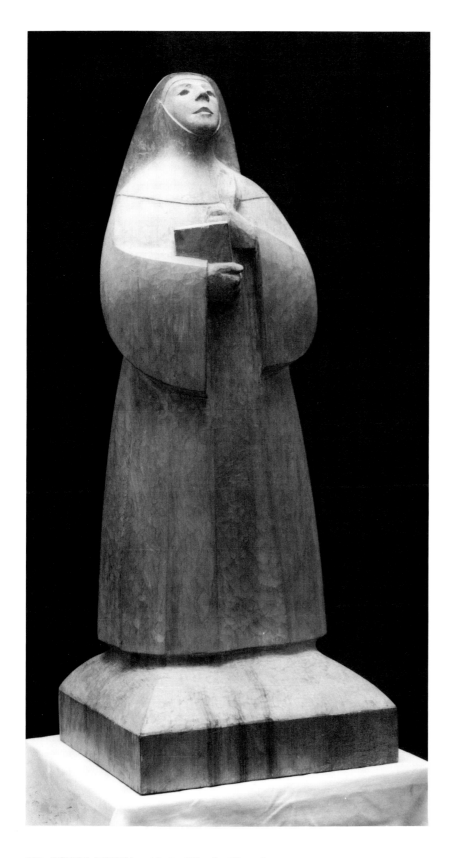

ST. SCHOLASTICA 1979 Wood Ht. 35″
Collection: Private

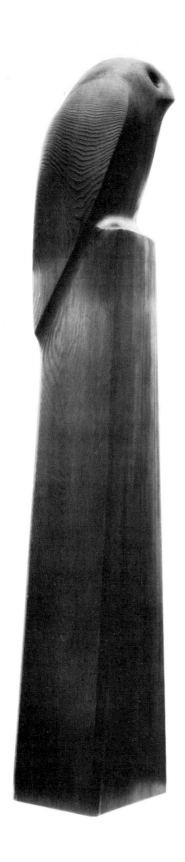

SOLITARY BIRD 1979 Cedar Ht. 41″
Collection: Pacific Northwest Bell, Seattle

BIOGRAPHY	1928	Born in Bellingham, Washington, November 14
	1954	B. A., Sculpture, University of Washington
	1954	Assistant to Henry Moore, England
	1954	Marries Anne McFetridge in England
	1955	Independent work, New York
	1955	With family, settles on Guemes Island, Washington

AWARDS	1954	Ruth Nettleton Award, University of Washington
	1954	University of Washington School of Art Prize
	1957	Norman Davis Award
	1960	Certificate for Superior Design and Execution, American Institute of Architects
	1964	Washington State "Artist of the Year," First Governor's Invitational Art Show, Olympia
	1965	Irene D. Wright Memorial Award

PUBLIC COLLECTIONS

Seattle Art Museum; Tacoma Art Museum; Art Museum, Anchorage, Alaska; Whatcom County Museum, Bellingham, Washington; University of Oregon, Eugene; Museum of Contemporary Art, La Jolla, California: Phillips Gallery, Washington, D.C.; St. Louis Art Museum; Detroit Museum of Art; Whitney Museum of American Art, New York

ONE-MAN EXHIBITIONS	1960	Willard Gallery, New York
	1965	Willard Gallery, New York
	1968	Willard Gallery, New York
	1970	Willard Gallery, New York
	1961	Seattle Art Museum
	1964	Washington State Capitol Museum, Olympia
	1964	Art Gallery of Greater Victoria, B.C., Canada
	1970	La Jolla Museum of Art, La Jolla, California
	1970	Anchorage Historical and Fine Arts Museum, Anchorage, Alaska
	1980	Tacoma Art Museum, Tacoma, Washington

GROUP EXHIBITIONS	1957	Museum of Art of Ogunquit, Maine
	1958	Chicago Art Institute
	1958	Pennsylvania Academy of Fine Arts, Philadelphia
	1958	Detroit Art Institute
	1958	Contemporary Art Gallery, Houston, Texas
	1959	Santa Barbara Museum of Art, Santa Barbara, California
	1960	Dallas Museum for Contemporary Art
	1960	De Young Memorial Museum, San Francisco
	1960	Los Angeles Municipal Art Gallery
	1960	Galerie Claude Bernard, Paris
	1961	Walker Art Center, Minneapolis
	1961	University of Illinois, Urbana
	1966	Phillips Gallery, Washington, D.C.
	1966	State of Washington Governor's Invitational Show, Japan
	1966	Corcoran Gallery, Washington, D.C.

GROUP EXHIBITIONS 1967 Museum of Art, Akron, Ohio
1968 Finch College Museum of Art, New York
1968 Rutgers University, New Brunswick, New Jersey
1969 Grand Rapids Art Museum, Grand Rapids, Michigan
1970 La Jolla Museum of Art, La Jolla, California
1975 Washington State Capitol Museum, Olympia
1976 Portland Art Museum, Portland, Oregon
1978 Whitney Museum of American Art, New York
1979 Montana State University, Bozeman
1980 Brigham Young University, Provo, Utah

BIBLIOGRAPHY 1967 Dore Ashton, *Modern American Sculpture*, Abrams, New York
1967 Faith Medlin, *Centuries Of Owls*, Silverline Press, Norwalk, Connecticut
1970 James J. Kelly, *The Sculptural Idea*, Burgess Press, Minnesota
1980 Donald W. Thalacker, *The Place of Art in the World of Architecture*, Bowker, New York and London
Art in America; Art News; Time Magazine; Saturday Review of Literature; Puget Soundings; Pacific Search Magazine